COYOTE

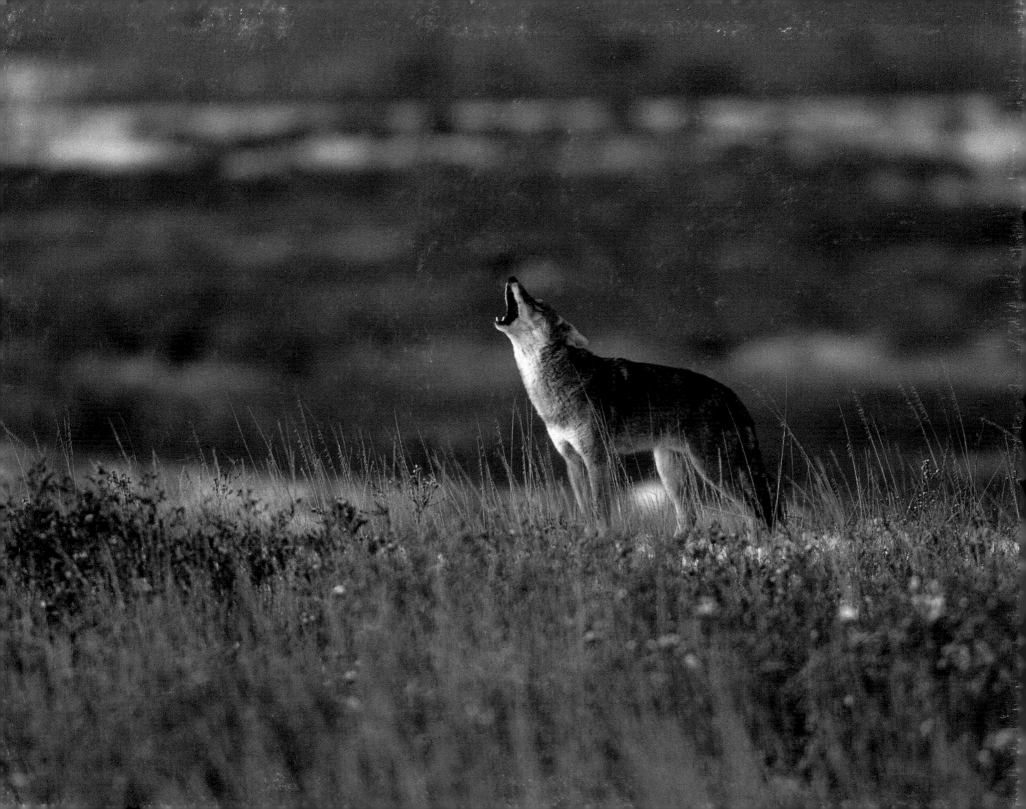

COYOTE

WYMAN MEINZER

TEXAS TECH UNIVERSITY PRESS

This book was set in Palatino and printed on acid-free paper that meets the guidelines for permanence and durability of the Committee on Production Guidelines for Book Longevity of the Council on Library Resources.∞

Design by Dwain Kelley

Coyote © John Nieto, the art appearing on page 11, is used with permission of the artist.

Printed and manufactured in Hong Kong by Oceanic Printing Company

Library of Congress Cataloging-in-Publication Data
Meinzer, Wyman.
 Coyote / Wyman Meinzer.
 p. cm.
 Includes bibliographical references (p.).
 ISBN 0-89672-352-6 (cloth : alk. paper). — ISBN 0-89672-353-4 (pbk. : alk. paper)
 1. Coyotes. 2. Coyotes—Pictorial works. I. Title.
QL737.C22M44 1995
599.74′442—dc20
 95-31162
 CIP

95 96 97 98 99 00 01 02 03 / 0 9 8 7 6 5 4 3 2 1

Texas Tech University Press
P. O. Box 41037
Lubbock, Texas 79409-1037 USA
1-800-832-4042

Also by Wyman Meinzer from TTUP
The Roadrunner

and with Jim Steiert
Playas: Jewels of the Plains

DEDICATION

To our wild lands and the creatures therein

PREFACE

As a kid, I would lie awake on my bed in the late evening hours and listen to the wind play through the brush beyond my bedroom window. On these winds rode the sounds of a summer night: a solitary mockingbird, the mysterious poorwill, or the hoot of an owl in the brush along the river. But the night offered more in the hours just before dawn—somewhere beyond the old rock fence, shielded by mesquite brush and yucca, padded feet paced silently in the darkness. The coyotes would always come. Perhaps they were visitors from the Brazos River bottom to the south or a band of hungry travelers from the badlands to the west—I never really knew. I knew they were there for the dogs would grow restless—growling on occasion and moving about the yard expectantly. But to my disappointment, the coyotes would never show themselves. Soon all would be quiet and I would drift into a fitful sleep. Fascinated by the creatures I could not see, their restless images soon drifted into my dreams. With frighteningly large eyes, coyotes stalked my every move, finally chasing me from dreams until I'd awake in a state of fright.

Almost four decades ago my first memories of the coyote became indelibly imprinted in my mind—eyes reflected in the headlights of the ranch truck as a coyote lingered momentarily alongside the road, or the serenade of yaps and howls I heard each night as they moved in and around the ranch headquarters, watching and waiting for an unlucky chicken that roosted too low to the ground. In sleep they visited my dreams, and by day I gathered enough courage to venture into their domain and search for tracks, hoping to catch a glimpse of the creature that had captivated my imagination.

After almost forty years of interacting with coyotes, I remain intrigued by them, but the dreams no longer occupy my nights. I have often wondered if perhaps it was those dreams, combined with the impressionable mind of a youngster, that fueled a lifetime interest in one of the most celebrated and controversial mammals in western American history.

The coyote has played a leading role in Native American beliefs and legends for centuries. Intrigued by the cunning and trickery of the creature, stories continue to be handed down through the generations, captivating audiences in the twentieth century as in the days of old. I can only speculate that because of a trickle of Native American ancestry, I inherited this fascination with the coyote. Perhaps they un-

derstood something about the magnetism of this creature that twentieth-century scientists, poets, and laymen have yet to fully grasp. I can say that an unrelenting desire to seek and understand the natural history of coyotes and the somewhat spiritual connection I feel with these creatures has been the motivation and direction that has led me to the life I know today.

To effectively convey the life way of a wild species to the reader in either words or as art, an understanding of and appreciation for the very existence of the animal is necessary. Sometimes the complexity of human nature becomes an unnecessary stumbling block for embracing unbiased facts so needed to present the full picture. The coyote, surrounded by a veil of controversy for over half a century, remains an animal whose complete story should be known.

While engaged in photography for most of the pictures in this book, I worked exclusively on large ranches that offered some of the best plains habitat for coyotes in the state. These coyotes are all wild creatures, born in total freedom, and live out their lives in the open ranges of the Southwest. Extremely wary of human activity, I found it necessary to establish blinds made of natural material and hide in them until the coyotes came into camera range. To draw the animals to my locations I was given several cow carcasses, animals that had perished from disease. Locating three different photo spots about one mile apart, I divided my time between each location. This enabled me to record much of the interaction between animals which would otherwise have not been possible.

In this book I cannot promise to answer all the questions concerning the coyote. Instead, from the standpoint of a naturalist, hunter, photographer, and student, I hope to convey the coyote way as I have known it for over half a lifetime.

ACKNOWLEDGMENTS

After thirty-odd years of working with coyotes, my trails have brought me in contact with so many helpful people that I fear for lack of space to adequately name them all. Little of the information here would have been available without the help of so many, and I want to extend my deepest appreciation to all that I possibly can.

Without a doubt my mother, Earlene Meinzer, and father, the late Pate Meinzer, deserve much thanks for maintaining a measure of heroic patience as they watched in wonder the antics of their nomadic son roaming the hills and plains in search of the coyote. And to my brother Rick for accompanying me on many forays in the brush for data, turning an otherwise lonesome job into often memorable occasions.

To obtain the mass of material and knowledge to put this book together, I had access to over a million acres of ranchland. To the following people I am forever indebted: Bob Moorhouse, Jim Humphreys, Tom Moorhouse, Jeff Haas, Kynn and Trina Patterson, O.L. Patterson, Mrs. Bobby Burnett, Bruce Burnett, Lewis Lyles, Red Livingston, Jim Pratt, Charles Durham, Paul Ingler, J.J. Gibson, Bill Springer, George Beggs, Bill Stone, Bill and Donnie Ryder, and Jack Brown. Through the gates of these ranches, I had access to perhaps the finest coyote habitat in the plains. It was, without doubt, the most complete and expansive classroom in the state of Texas.

During my years of study at Texas Tech University, a few key individuals in the field of academia must be given credit for directing me in the difficult task of scientific observation. Darrel Ueckert, Jerran Flinders, and Fred Guthery exhibited unwavering patience and gave direction in making my research projects worthy of recognition.

COYOTE

Animals played an integral role in American legend, even before the beginning of written history. Native American tribes spanning the continent revered various indigenous species, elevating some of them such as the raven, bear, and coyote to the status of gods and crediting these "first animals" with the creation of the universe and many of the inhabitants therein.

One of the animals that frequently appears in Native American and Anglo literature and mythology is the coyote. Called *coyotl* by the Aztecs and *coyote* (kayo ti) by Spanish-speaking Mexicans, the early Anglo pioneers sometimes referred to this animal as the prairie wolf, probably because its general physical appearance is similar, but smaller, than the plains or gray wolf. Throughout the western United States traditional storytelling among a number of the indigenous tribes reveal the coyote as a leading figure. The coyote functions in two ways, as a deity endowed with supernatural abilities or as an animal figure of legend, displaying a variety of personalities as he scurries through fact and fiction.

This, of course, includes thief, trickster, lecher, outlaw, and a variety of other roles. Ironically, despite the many bad characteristics attributed to both the coyote of myth and the animal *Canis latrans*, many modern-day writers have adopted the coyote and herald its antics to readers of contemporary western and southwestern literature.

Although the coyote has been one of America's native species for over a million years, and has been well-documented in the oral history and art of Native Americans for centuries, this species has been in the forefront of Anglo attention for less than one hundred years. This shy and retiring canine was relatively obscure in the writings of early Anglo explorers and settlers. Mark Twain was among the first writers to give written accounts of the coyote during his travels in the west. Although Twain's description of the creature was not always flattering, a hint of respect and admiration for the coyote is evident throughout his narrative.

The coyote is a long, slim, sick, and sorry-looking skeleton, with a gray wolf-skin stretched over it, a tolerably bushy tail that forever sags down with a despairing expression of forsakenness and misery, a furtive and evil eye, and a long, sharp face, with slightly lifted lip and exposed teeth. He has a general slinking expression all over. . . . When he sees you

3

he lifts his lip and lets a flash of his teeth out, and then turns a little out of the course he was pursuing, depresses his head a bit, and strikes a long, soft-footed trot through the sagebrush, glancing over his shoulder at you, from time to time, till he is about out of easy pistol range, and then he stops and takes a deliberate survey of you; he will trot fifty yards and stop again— another fifty and stop again; and finally the gray of his gliding body blends with the gray of the sagebrush, and he disappears. *Roughing It*

Smaller than its cousins, the gray (or great plains) wolf (*Canis lupus*) and the red wolf (*Canis rufus*), the coyote was considered a minor nuisance for decades. Always lurking in the shadow of the gray wolf, chasing prairie dogs and generally scrounging for survival, the coyote rarely elicited more than a unkind word from frontiersmen and settlers. As the western frontier continued to recede in the face of Anglo settlement during the late nineteenth century, many species of animals were either pushed into more remote corners of their historical range or almost eliminated by overhunting. With their natural prey species decimated, predators, namely the wolf, turned to livestock for survival. Armed with strychnine and large steel traps, settlers initiated a relentless and far-reaching war. With only a vestige of its former wilderness remaining, the wolf was finally extirpated from the western ranges of the United States shortly after the turn of the twentieth century.

With the wolf eliminated from the top of the food chain, the coyote was the natural successor. Highly adaptable, the coyote quickly filled the void once occupied by the wolf. Perhaps because the coyote looked like a smaller version of the wolf, coupled with its predation on sheep and to a lesser extent cattle, public sentiment against the coyote was so strong that by 1915 the United States government entered the battle front. The Bureau of Biological Survey, now the United States Fish and Wildlife Service, launched one of the largest predator control efforts in American history. Through the combined effort of private, local, and state control campaigns, approximately twenty million coyotes were destroyed in less than one hundred years.

With such staggering numbers to verify America's war on the coyote, it would seem that *Canis latrans* should be a likely candidate for the endangered list. This is hardly the case. Once limited to the area between the Mississippi River and the California mountains and spanning into Mexico, by the 1930s the coyote had expanded its range northeastward and could be found in western Pennsylvania. By the 1950s coyotes were reported as far as New England, and today

they are found from the Bronx to LA, Hudson Bay to the Everglades, and northern Alaska to Costa Rica. Even Guatemala has bragging rights to coyotes as the feisty creature adapts to this extreme southern boundary of it range.

Adaptability is the key word to the success of the coyote in overcoming its seemingly insurmountable odds over the past several decades. From heated battles on the western ranges between livestock growers and environmental groups, to romance and intrigue in legend and song, the coyote continues to be an integral part of our cultural and economic structure, a fact that has remained largely unchanged from centuries past. It is ironic that both ancient and early contemporary legends foretold of the tenacity of the coyote, subtly hinting that the coyote could very well be the last creature to inhabit the earth.

HISTORY

The ancestor of the coyote dates back some three to twelve million years ago in the Pliocene epoch when a variety of predatory doglike creatures stalked the land. Of these, a small foxlike creature was most likely the ancestor of the coyote. The coyote evolved as the most primitive member of its genus in North America. "Primative" means that it is less specialized, and this may be the reason for its incredible success in the face of such adversity during the past century.

Dire wolves lived during the Pleistocene epoch (two to four million years ago). These large carnivores were specialized in their hunting methods and prey selection. Large-scale climatic changes occurred at the end of this geologic period, which caused many animal species to perish, including the key prey animals needed for survival by many of the large carnivores. Small predators, such as the foxlike predecessor of the coyote, were more adaptable in their food selection. They required much smaller prey species as well as vegetative material for survival. The small canids successfully made the transition into the present period, whereas dire wolves and many other large predators became extinct. From one of these came the North American gray wolf, *Canis lupus*, who flourished across the continent for thousands of years. Like its predecessor the dire wolf, and unlike the coyote, the gray wolf is a specialized creature requiring large prey for its existence.

The earliest fossils known that resemble the modern coy-

ote were found in Cumberland Cave, Maryland and date from the Pleistocene. To understand the fate of these modern canids, it is not necessary to unravel their mysteries from fossils and prehistoric bone beds. Written history records the demise of the wolf to its present questionable status. A product of its specialization, the wolf continues to struggle in the face of encroaching civilization, whereas the coyote flourishes and expands its range across the continent.

Countering adversities throughout the ages could be one of the key factors in the coyotes continued popularity in story and song. Long before contact with Spanish and Anglo explorers, Native American tribes herald the coyote in legend. Referred to as god-like, the coyote emerges in many tribal legends as a deity, the creator of mankind and the universe. This metaphysical coyote is popularized as good, often teaching man the art of hunting and other self-sustaining activities. On the other hand, the coyote in legend is portrayed as a trickster, often changing identity in order to achieve a less than honorable end. The butt of jokes, coyote falls victim to his own ploys, similar to the central plot of the popularized cartoon series "The Roadrunner and Wylie Coyote."

Contemporary literature has mirrored the notoriety given this animal through the centuries. Ballads, stories,

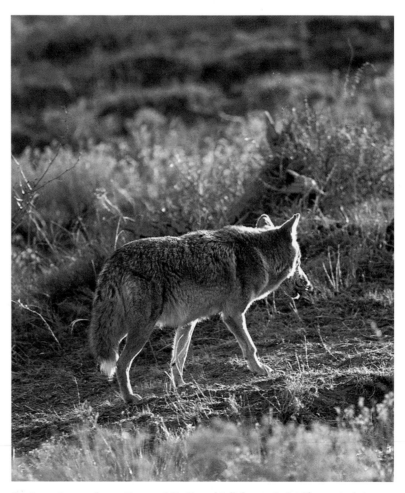

Contrary to popular notion, a white-tipped tail does not signify a cross between a coyote and dog.

and poems are increasingly devoted to this survivor. Perhaps we are fascinated with the coyote because it is a survivor, and as such exhibits several traits we pride ourselves with—adaptability, intelligence, and resiliency. They continue to captivate our imagination as we struggle to understand our connection with this enduring creature we have tried for so long to destroy. And perhaps we finally realize what the "ancient ones" have known all along; that the coyote is a special creature, as primitive as he may be, and is an essential part of our natural heritage that deserves a rightful place in this world.

DESCRIPTION

The old adage "beauty is in the eye of the beholder" certainly holds true when trying to find a description of the western coyote. Some writers find it difficult to give an unbiased description of the coyote; their disdain for the creature becomes evident within the first sentence. Adjectives like filthy, sorry, sneaky, and miserable are a few that come to mind. But after almost thirty years of working with coyotes, I find these descriptions to be somewhat inaccurate at best. Instead, I have found these animals to be intelligent, exhibiting amazing adaptability and cleverness second to none.

I have photographed and watched thousands of coyotes over a span of decades in every phase of their lives. From the heat of mid-summer to the exhilarating days of late autumn, I have watched a coyote transform from a flea-covered, one-pound fuzzball whelp to a glistening, furry jewel that moves with fluid grace across the plains. But to describe the coyote honestly one must consider every aspect of the creature, giving consideration not only to the physical characteristics but also the heart and spirit that lies within. For it is the latter that has fascinated humans over so many centuries. For the individual who might not be lucky enough to see a wild coyote in its natural environment, or even see one at all save for a visit to the zoo, a brief description is in order.

Coyotes, dogs, wolves, and foxes are all classified as members of the family Canidae. All canids have a relatively long slender rostrum; sharp, pointed canine teeth; and non-retractible claws. Domestic dogs are believed to be derived from a wolf type ancestor. In color and general form, coyotes look like a smaller version of the wolf: their ears are

longer, the skull narrower and shorter, and the bone structure lighter than a wolf. There is some overlap of characteristics among the red wolf, coyote, and domestic dog. The extent of this overlap is ambiquous because coyotes occasionally interbreed with wolves and dogs and bear fertile young. Possibly the one characteristic that defines the coyote as well as any are the facial features. With ears that measure three to four inches in height, narrow-set eyes with a yellow iris and dark pupil, and long snout, the coyote is the classic predator. Countless times I have peered through the long lens of a camera at the burning stare of a suspicious coyote and marveled at the intelligence those eyes seem to convey.

As with all members of the dog family, the coyote's pelt possesses two layers of hair, an outer layer of longer, coarse guard hairs and a finer, shorter underfur. Coyotes generally have one main molt between late spring and autumn. The summer coat is shorter and thinner and the animal can appear somewhat scraggly. With the onset of autumn the underfur becomes thicker and silkier and the guard hairs lengthen. The winter coat traps heat five times more efficiently than the summer coat, thus providing excellent insulation against the extreme winter weather.

The coyote, *Canis latrans*, occurs across its expansive range in a variety of color schemes. The coat color is a mixture of black, cream, yellow, gray, and brown; the predominate color varies with geographical region. Gray to light brown seems to be the basic color with multitudes of variation between. Coyotes that live at higher altitudes tend to be grayer and blacker than those that live in desert regions, which are lighter and more yellowish brown.

At first glance *Canis latrans* might appear to be a much larger animal than it really is. This seems to be more evident in the winter when the thick fur belies a small body frame beneath. As with color variation, the size of the coyote also varies with geographic locality; the largest animals occur in the northern extent of their range and the smallest in the south. Those on the Texas plains stand approximately twenty-two inches tall at the shoulders, a mature adult male averages twenty-four pounds in weight and measures forty-five inches from the tip of his nose to the tip of his tail. The tail is about fourteen inches long. A female usually weighs an average of one to three pounds less, and is an inch or two shorter in height and length. The largest male animal that I have weighed tipped the scales at forty-one pounds.

Determining the gender of coyotes in the wild is possible by studying the physical characteristics of the animals, spe-

cifically the face. Trotting across the desert or plains, body size will not reveal the sex at first glance, unless two animals are together for a comparative inspection. Facial characteristics are the most reliable means of determination. The male possesses a broad face and coarse features; in contrast, the female exhibits a comparatively more slender nose, narrow-set eyes, and a generally more slender body frame. Although these criteria are not useful to the casual observer, I have found them to be accurate about eighty percent of the time during my field work.

As with many wild canines, the back feet of the coyote are slightly larger than the front. The front feet have five toes (one of which is the dewclaw), the hind feet four. While walking, the coyote has a stride of about nine to twelve inches, depending on the size of the animal. Large males have a longer stride than females. Running, it is not unusual for their stride to exceed three or four feet.

With long, thin legs, the coyote is physically endowed for traveling long distances at an elevated rate of speed. Although capable of attaining speeds up to about thirty-five mph, the coyote most often is seen trotting across rangeland, ever alert for an opportunity to pounce on one of its many prey species.

The initial burst of speed that the coyote can attain is re-

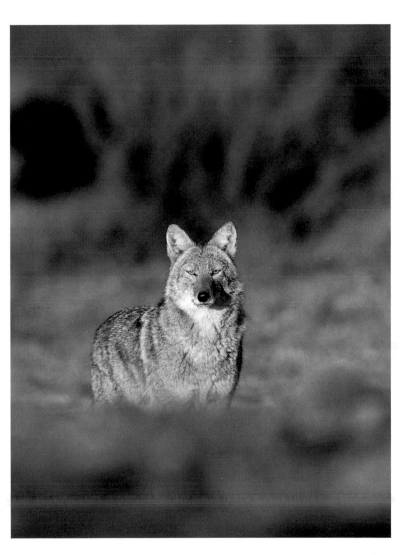

markable. One day while driving across several miles of open plains country, I noticed a pair of adult coyotes trotting leisurely through the yucca and little bluestem grass. I grabbed my binoculars and watched for a minute. The coyotes paid me little mind as they distanced themselves from my vehicle. Suddenly, in an incredible show of acceleration, the male rocketed at full speed for about twenty yards and then started trotting again. Glancing back at me, I was amazed to see him carrying a jackrabbit in his jaws. Vigilance combined with remarkable acceleration allowed the coyote to capture one of the most fleet-footed creatures on the plains. Had I blinked when the jackrabbit flushed from hiding I would have missed the entire show.

FOLKLORE AND MISCONCEPTIONS

The old rancher was serious as he detailed the description to me. "We have two kinds of coyotes here," he said. "The ones with the long crooked noses are the worst. They have real dark fur, and they are more apt to eat calves than the other type." I had just been exchanging friendly words with him over the issue of coyote predation on cattle. As he spoke, I tried to remember if any of the several thousand coyotes I observed over the years possessed those characteristics. I had seen the color scheme he described on hundreds of coyotes. Many individuals possess very dark, grizzly guard hairs along their back and sides making them look almost black. But the crooked nose I couldn't buy.

Fallacies and misconceptions have been a part of the coyote's life story since the first wagon wheel cut its indelible mark in the plains of early America. The Native American people understood the ways of our natural fauna far better than the Anglo pioneers of the eighteenth and nineteenth century. The early inhabitants of the plains—the Clovis, Folsom, and Plainview peoples—competed directly with many wild species for resources and learned to respect and coexist with them. Unfortunately, present-day suburban and urban America has little or no idea about the role that many of our wildlife species play. With minimal knowledge or experience to understand the interactions within our ecosystem, it is little wonder that so many misconceptions continue to exist. The wolf is a case in point. Although the

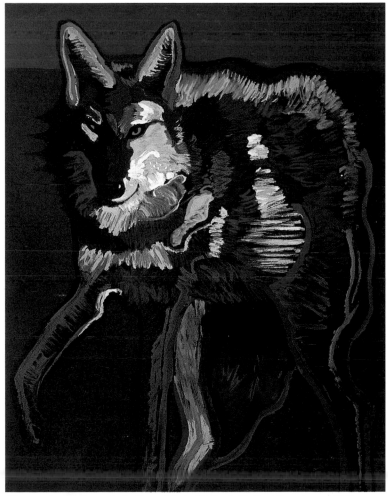

The coyote continues to be the subject of today's Native American artistic efforts. (Coyote © John Nieto, used with permission)

plight of the wolf seems to be improving, old myths continue to create fractures in the critical link of public enlightenment, a necessary means by which the factual story about *Canis lupus* can successfully displace the legendary monster image that has been perpetuated for centuries.

Folklore and legend have played a major role in the concept of the coyote's lifeway and personality. Unfortunately, many of these tales were born early in the century when unfounded wives tales were considered ample evidence for identifying the coyote with an air of contempt. Even today, attitudes toward the coyote continue to be influenced by folktales born decades ago.

References have been made through history about the reticent personality of *C. latrans*, referring subtly if not blatantly, that his cunning is exceeded only by his cowardice. Personally, I have never met a coyote that even bordered on cowardly. Respecting humans for what we are—a dangerous foe—and doing its level best to evade contact with the enemy is by no means criteria for cowardice. The resiliency and intelligence these animals show is unquestionable if only in their emerging the victors after a one-hundred-year war declared by man.

A belief that is especially dominate where coyote populations have not been allowed to attain maximum or near maxi-

mum densities, is that if left unchecked, coyote populations will exceed the carrying capacity of the region. Such tales evoke visions of gaunt and starving coyotes stalking across the range. Unlike mankind, coyote populations are density dependent. Populations normally will not exceed the carrying capacity of the land. When coyote numbers have achieved a certain level, some move to other regions and set up house where ample food and cover are available. Blessed with a physiological barometer, free-ranging coyotes will not allow their numbers to exceed an ecologically safe limit.

Other misconceptions include that coyotes prey to a significant extent on livestock and they spread noxious plants such as mesquite across the range.

HABITS AND BIOLOGY

The coyote has adapted to a wide range of habitats and climatic conditions within its range. Unlike many wildlife species, *Canis latrans* rarely exhibits habitat specificity, and adapts well to almost all geographical areas in North and Central America. The coyote lives comfort-

ably in the harsh desert environment of the Southwest as well as in the forests of the Canadian Rockies. They seem well suited to hunt crayfish and frogs in the swamps of Louisiana and grow fat on mesquite beans and beetles on the plains of Texas.

My introduction to the ways of the coyote began when I was old enough to ride horseback across the plains and badlands along the Brazos River observing the wildlife. Specific pastures on our ranch harbored more game than others, and I waited eagerly for Dad to announce he would be working in Red Creek pasture. Composed largely of silt and clay badlands, Red Creek pasture comprised about 3000 acres and harbored an abundance of coyotes. In spring, I could always ride upon a cluster of young coyote pups sunning on a hillside above their den, and in the winter while feeding the cattle, we would see coyotes nosing around the calving grounds, consuming afterbirth and calf droppings.

As a teenager I had my first opportunity to observe coyote behavior first hand when a cowboy unearthed a coyote den and gave me one of the male pups. I collared him with the unlikely name of "Cusschidus" and grew to love that skinny, long-legged pup. "Cuss" never knew the confinement of a pen. Always allowed to run free, he was wary of strangers and disappeared whenever an unfamiliar face ap-

The badlands of North Texas have dense stands of juniper. Juniper berries provide a significant food source for coyotes during autumn and winter.

13

peared. As Cuss grew older he became more nocturnal, leaving the house at dawn and staying hidden all day. Sometime after darkness had settled and the stars shown brightly above our beds, a rustle of grass near the yard gate told us that Cuss was back. All night he wrestled with our old and ill-tempered curr dog "Wheezer." At dawn, after breakfast, Cuss would disappear for the remainder of the day. Then at nightfall the routine would be reenacted. About mid-summer Cuss had to face a transition. Being the coyote that he was, the chicken pen proved to be too enticing for an animal known for its voracious appetite. Despite my pleadings, my parents ordered me to take Cuss far away and release him into the wild. My last view of little Cuss was through tear-filled eyes as he trotted nonchalantly into the night and out of my life. I've never forgotten him.

One of the most vivid examples of the coyote's resiliency occurred over thirty years ago when my father announced that he had just observed a coyote that was completely scalped, having nothing above his eyes but raw flesh. Apparently someone had run over the animal along the highway and assumed him dead. Because the bounty system was active then, the driver scalped the coyote and headed for the county courthouse to collect the $1.50 bounty. Apparently the animal was only knocked unconscious by the vehicle and drifted into the brush when he recovered. Although still alive, the unfortunate animal was deaf. Dad had approached the coyote from behind and had almost ridden up to him before the creature spotted the horse. From time to time we would see "no ears" in the same pasture, always vigilant and apparently in good physical condition. After a while he disappeared. We assumed that the old warrior had succumbed to natural causes or perhaps an infection, thus relieving him of at least some of the suffering he had endured over the years.

About two years after we had first seen old "no ears," the local government trapper drove up to our home and invited us out to his truck. There, in the back of his vehicle, lay the coyote. Apparently disturbed by all the human activity in his home range, the coyote had shifted his activity several miles to the north where he was subsequently captured. Parts of his scalp were still scabbed and partially raw. How the coyote kept maggots and screw worms from invading the wound is subject to speculation. The overall condition of the animal was remarkable in that he appeared fat and had attained an age considered old by coyote standards.

Several aspects of coyote behavior have been the subject of debate but few seem to be of more interest than their eating habits. Broaching the subject elicits many colorful responses,

In areas where juniper berries are available, these berries comprise approximately ninety percent of the coyote's diet from October through January.

especially if discussed in sheep-raising areas. In cattle country, the coyote is not considered a serious menace to livestock, although some predation occurs in isolated instances.

Most reports about the food preferences of coyotes mention that although their diet is varied, the preponderance of food items in their diet are small mammals. On our ranch, red berry juniper and mesquite trees were the predominate brush species. As a youngster I watched coyotes gorging on the fruits of both shrubs when they ripened—mesquite in the summer and juniper in the fall and winter. Sometimes we would see coyotes within view of the road as they fed on the putrefying carcasses of animals that had died from disease or old age during the late winter season.

Having been reared in cattle country with the opportunity to observe coyotes in association with cattle for many years, I decided to embark on a study of the culinary preferences of coyotes to determine exactly what they ate in the Rolling Plains of Texas.

The Rolling Plains were historically a rolling, shortgrass prairie interspersed with broken canyonlands often referred to as badlands. After the demise of the buffalo herds in the late 1870s, ranches were established, and cattle replaced the once innumerable bison. Encouraged by drought, overgrazing, and the almost complete disappearance of an-

nual grass fires, numerous undesirable shrub species invaded the Rolling Plains. Prickly-pear cactus, juniper, and the noxious mesquite tree are the nemesis of this almost exclusively cattle-raising region. The coyote found this new vegetative growth to be ideal for survival. Once restricted to scavenging the remains of wolf-killed buffalo or chasing rabbits and rodents for survival, today's coyote dines on mesquite beans, prickly-pear apples, and juniper berries for about nine months of the year and does quite well. During the late winter season when these resources are depleted and conditions become stressful, the adaptable coyote shifts to scavenging on dead cattle or chasing rabbits until the spring growing season arrives.

One of the primary reasons why the coyote can flourish throughout its range is its omnivorous lifestyle, incorporating a wide variety of items into its diet. Unlike the wolf, the coyote easily converts to a vegetarian lifestyle when meat is not available. I found that unless forced by shortages of various types of berries, coyotes hunt rabbits and rodents only sporadically. In May of 1971 during my first year of dietary research, adequate spring rains lent to a bumper crop of lote berries, a purple and rather mundane-tasting fruit produced by the lote or chaparral bush. Stomach analysis and scat samples showed that this berry was the

dominant item consumed by about ninety percent of Rolling Plains coyotes. One year later, during the same month, a dry spring caused an almost complete failure in berry production on the lote bushes. Comparative analysis showed that the coyotes simply made a transition and consumed mostly rodents.

The variety of food types exhibited in the coyotes' diet reflects the complexity of the available food base. Generally, the southern ranges occupied by *C. latrans* offers a greater selection of food items than the northern regions. The Rolling Plains are a veritable smorgasbord during a large part of the year. Beginning in May and lasting into autumn, the menu offers the fruit of lote, mesquite, prickly pear, chittum, elbowbush, hackberry, juniper, algerita, and wild plum. To the dismay of farmers, coyotes consider watermelon a delight where available. Many insect species are consumed but those most sought are locusts, cicada, and four o'clock beetles. Occasionally a quail or other small bird or the odd lizard or frog will fall prey to this creature's appetite.

Coyotes were once thought to be the vectors for dispersing the seeds of noxious plants such as mesquite and juniper. Only twelve percent of the mesquite seeds taken from coyote scat germinated when placed under ideal growing conditions in a lab. Approximately eight-five percent of the

same number of seeds found under normal conditions successfully germinated in the lab. Apparently the coyote's digestive system renders these seeds inviable; thus debunking the belief that this species is guilty of dispersing mesquite across the range.

On the Rolling Plains, late January through April is when the coldest weather occurs. Ice storms, snow, and incessant winds dominate the weather patterns. Scat samples reveal that a few coyotes can still find a few juniper berries and mesquite beans to eat. Most of these seeds are from wood rat middens where these rodents cache these delicacies earlier in the year. Foraging coyotes, in their attempt to unearth the wood rats, find the berries and beans and summarily devour them.

Cannibalism occurs frequently in the population during this stressful late winter period. Coyotes do not seem to shy away from the prospect of feeding on their own dead if conditions are severe. Individuals that perish along highways are often consumed, leaving behind the tail and a few entrails as the only evidence. Many times I observed the carcass of a dead coyote and returned to find it devoured by the following day.

Livestock predation also occurs during this time of high stress. On cow-calf operations, calving generally occurs in late winter and early spring. Coyotes, probing the hangouts of mother cows, often feed on the placenta and feces from the young calves. Young first-calf heifers, unlike older more protective cows, are often too tolerant of roving coyotes and sometimes leave the newborn calves unattended. For the majority of coyotes, it is a prime opportunity to mix with the young calves and feed on the rich feces at will. But to a given few, it is an opportunity to chew the tails and buttocks

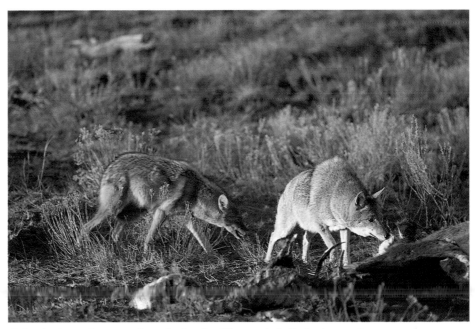

A dominate coyote approaches a food cache. The coyote in the background exhibits the characteristic body posture of a submissive animal.

17

of calves, often killing the animals in the process.

Although not considered a significant problem on most cattle ranches, coyote predation can present a problem in localized areas year after year. A few years ago I was contacted by one rancher who complained that a coyote or coyotes had developed a taste for calf tails in one pasture on his ranch. On the whole, the rancher appreciated coyotes and enjoyed listening to their yips and howls across the badlands, but too many calves were appearing with little or no tails. Something had to be done. My brother and I were invited to remove the problem animal with our rifles. In the pasture, we walked into the mesquite and tabosa-grass river bottom and located a site near a herd of cattle. After a few moments of using a varmint call, the cattle became curious of the two crouched figures and approached our position. To our surprise a large male coyote was mixed in with the young calves, all approaching our position at a trot. A few days after removing the coyote, the rancher informed us that no more tailless calves had appeared.

Killing cattle, even young calves, is an activity only a small percentage of coyotes engage in. A newborn calf outweighs a coyote by almost four times. Because coyotes seldom kill in packs and it is very difficult for a single animal to take down such a large prey item, it is easy to see why *C. latrans* would resort to attacking livestock only under extreme stress. During the thirty years that my father ran a ranch in the Rolling Plains I never recall him complaining about coyote predation on cattle.

Several times over the past twenty years I have observed fascinating feeding or hunting behavior in coyotes. On one occasion I was perched on the crest of a high hill enjoying a rather pleasant winter day. The sunlight was intoxicating and a light breeze from the north barely stirred the buffalo grass. Scanning the rolling grassland below with binoculars I soon spotted the movement of a foraging coyote. Juniper shrubs spotted the region and were loaded with berries at the time. Most of the low berries had been picked over leaving bright red clusters of the bitter morsels high up in the shrub. Soon the coyote disappeared behind a bush and did not come out. Within moments I saw the tree shaking and observed the coyote climbing through the limbs to the top. Reaching a location where the berries were thick the coyote began to devour all fruits close enough to grab. After finishing his meal the critter slid down through the limbs and trotted over the distant hill and out of sight.

An aspect exhibited by the coyote that many people find disgusting are its scavenging habits. Carcasses of cattle, horses, and other domestic livestock are fair game to coyo-

tes. In cities and parks, trash dumps and open trash containers are visited regularly. Los Angeles residents have become concerned about the numbers of coyotes that roam the streets at night raiding trash cans and snatching pet cats and dogs. Some people even fear for their personal safety as the howls and yips of *C. latrans* echo through the alleys and streets. It is true that the coyote will prey on roaming cats and small dogs, but this is simply an example of how the coyote has been so successful in expanding its range in these modern times. He has proven that he can coexist with people and do well in the process.

HUNTING AND PREDATION

In the plains region the coyote maintains a rather solitary lifestyle. Exceptions occur late in the summer when family units are still strong and in late winter during the mating season. Pairs and small packs occasionally are observed at other times, but this is the result of animals converging at a common point to loaf or hunt. Not to be confused with the wolf's habit of hunting in packs, coyotes often gather in a given area such as a wheat field where a concentration of cattle occurs. Here one can often view several coyotes wandering through the cattle looking for a meal of calf manure or perhaps dead livestock. In such a case the coyotes are generally working as individuals and not in a pack.

Throughout the years I have observed coyotes hunting at night as well as during the day. By far the largest percentage of sightings were of single animals. Coyotes are very thorough hunters, working slowly, listening and watching for any opportunity to capture prey. Wandering from bush to bush, they feed voraciously on mesquite beans or pricklypear apples during the summer. In autumn, I have observed coyotes using a buddy technique to work an area. The pair trots abreast through the brush maintaining a distance of several yards between them. If one suspects a rabbit or rodent to be hiding in a clump of grass or weeds, both coyotes will converge on the clump together. If nothing is found, they resume their hunt with a vigilant stare and ears erect, working the pasture with a technique often used by cowboys during a cattle roundup. Observations have been made describing coyotes chasing game in tandem, that is,

one coyote chasing while the other rests. Although I have never seen such behavior I have no doubt that it occurs.

A symbiotic relationship occurs between the coyote and the American badger that has intrigued people for centuries. Native Americans speak of the relationship, and folklore has maintained through history, the strange bond between the coyote and badger in life and legend. As strange as it may seem however, this relationship does occur with no dire consequences to either animal.

Research has suggested that coyotes often pair up with badgers and maintain a rather loose companionship during certain seasons of the year. Observed during a period when ground squirrels were particularly abundant, the coyote is ever the opportunist and allows the badger to pursue the squirrels underground via digging. If the squirrel evades the badger and escapes from the hole, the coyote readily pounces and captures a meal with a minimum of expended energy. Although observed on numerous occasions by various individuals throughout history, this unique pair do not seem to develop a close or lasting bond. It is basically a relationship based on convenience and the badger seems to be amicable to a point. Theories exist suggesting that the coyote enjoys an increase in hunting habitat when working in association with the badger. Without a doubt the relationship is benefi-

cial to both animals or the tolerance level exhibited by both would be too low to allow this phenomenon. But too, under adverse conditions, either animal would probably devour the other if the opportunity presented itself.

On two occasions I have observed coyotes hunting with badgers but circumstances did not allow me to see the scenario played to the end. In one instance the creatures were simply traveling together across the plains. At another time the badger was excavating a prairie dog hole while an attentive coyote lay only a few feet away.

The coyote is perhaps known best by rural Americans for his taste for chickens. Whether a farmer, rancher, or 4H member, coyotes show no partiality when it comes to a cackling pen of fat white leghorns. My father took great pride in raising chickens and we benefited from both the eggs as well as delicious meat deep fried for a Sunday meal. Our chickens were free to roam anywhere they pleased, which included in and around the mesquite thickets near the barn. Occasionally we would lose a few chickens to coyotes. The method of attack varied, but the end result was always the same. Sometimes a bold coyote would approach the chickens during the midday—on one snowy winter day some four or five coyotes stood about the pen staring at our chickens that fortunately had been locked up for the day. Most of

A coyote hunts along a ridgeline through the bluestem grass of the Rolling Plains.

the time, *C. latrans* would strike early in the morning or late in the evening, dashing quickly out of the brush to grab a hen and then escape. The only evidence would be some cackling hens and a few feathers scattered along the escape route. One thing was for certain though, once a coyote developed the habit of raiding the chicken house, few measures short of killing the raider would stop its forays.

Early one morning as I sat at the breakfast table Dad walked in and reminded me that several of his laying hens had disappeared during the past few days. Finishing my bowl of cereal quickly, I took my 30-30 rifle and a handful of cartridges and headed down the road. From previous investigations, I had determined that the coyote was approaching from the east, out of a densely wooded draw. Giving a wide birth to the chicken pen, I circled to the east and approached the pen with the sun at my back. Momentarily I spotted movement through the thick mesquite and saw a coyote carrying the lifeless form of a fat young hen. Our eyes met at almost the same instant. Dropping the hen, the animal headed north as fast as it could negotiate through the brush. On its heels came a fifteen-year-old boy and his 30-30, dodging brush and looking for an open shot. A wheat field opened up a short distance from our line of travel and I knew this would be where I had to make my move. The coyote was perhaps fifty yards into the field when I reached the old wagon that sat next to the field fence. With a wildly erratic aim I emptied the entire magazine of seven shots at the fleeing coyote and never touched a hair. But it was a lesson not soon forgotten by the wily coyote—it never returned to our chicken pen.

Little doubt exists that some coyotes develop a taste for beef and, at times, take the liberty of dining on calf tails and sometimes the calf itself if circumstances are right. What determines the making of a calf-stalker is largely a mystery. Some theorize that old coyotes are the most likely candidates. Too old to capture rabbits for food, they turn to preying on young livestock for survival. But many stock killers are healthy adults in their prime. In such cases the reason could be related to the dominance ranking of an individual animal and its willingness to attack larger game than is normal for the average coyote. Others maintain that coyotes turn to such detrimental activities in times of stress such as during late winter food shortages and during the whelping season. I have seen instances where all of these theories seem to apply. But the most common menace they pose to cattle is their habit of eating calf tails.

Almost all ranchers in the plains region can relate to the spring branding activity and counting the bobtailed calves

that show up in the roundup. For the most part, the coyotes' habit of eating calf tails is viewed as a natural aspect of ranching. It is considered an annual occurrence and not given much thought unless an excessive number of animals show up in the roundup. Again, theories abound as to why some coyotes develop a taste for tails, but it is obvious that only a small percentage of coyotes engage in this activity. The most credible theory relates to the coyotes' fondness for calf manure. Very young calves seem to be afflicted with chronic diarrhea, a result of mother cows producing milk too rich for the youngsters digestive system. Cows often walk away from their tiny calves, leaving them hidden in the brush or weeds until their return sometime later. Coyotes frequent the calving pastures and soon find the calves in hiding. Without the protective cows to drive the intruder away, the coyote begins to lick the manure that has collected on the calf's tail. A nip here and there might lead to blood loss thus encouraging an already hungry coyote to amputate the calf's tail.

One late winter some twenty-five years ago, my brother and I were working a pasture that harbored a herd of calving cows. My brother was riding down a draw when he caught sight of a coyote busily feeding on something in the high grass. Not wanting to approach too closely and frighten the animal, he studied the scene and soon realized that the coyote was indeed eating the tail of a calf. Lying motionless on the ground, the calf made no noise or effort to escape as the coyote nonchalantly removed the tail almost as clean as a surgeon's knife. The calf survived without any complications and grew to be a healthy adult.

Many unsavory stories circulate throughout the livestock industry regarding other "atrocities" inflicted by coyotes through the years. Most of these stories are isolated incidents where coyotes were being opportunists, and took advantage of an unfortunate situation. Heifers paralyzed by complications of birthing are sometimes victimized by coyotes. Sometimes injured cattle are almost eaten alive by hungry coyotes. These are uncommon incidents enacted by wild creatures exhibiting survival behavior.

A behavior that is not tolerated by livestock owners is that of a coyote or coyotes turned calf-killers. Sometimes a result of management practices and sometimes an opportunistic behavior gone awry, instances do occur when a coyote or pair of them develop the habit of killing young livestock. On most ranches such problems occur only periodically. Strangely enough, some ranches experience the problem only in certain pastures. It is as if a pair of adults are training their young to perpetuate the activity. Often it occurs in

cattle herds where the mothers are predominately young heifers, not yet instilled with the protective instinct of older cows. These young mothers have a tendency to walk away from a newborn calf, leaving it to die of exposure or from predation.

One such incident was observed by a rancher friend and the calf was subsequently saved. Stopping on the road to view some cattle one winter day, he heard the distress bawl of a calf. After walking to a vantage point, he observed two or three coyotes surrounding a calf that had been abandoned by its young mother. In their attempt to kill the calf they had torn the flesh from its nose and bloodied its hindquarters. Approaching the melee with shouts, the rancher succeeded in driving the coyotes away from the frightened calf. Such incidents do occur on occasion and can be addressed on an individual basis.

Deer, antelope, and coyotes have coexisted on the American continent for thousands of years. Predation on these ungulates does occur, sometimes even inhibiting population and range expansion in the process. Most predation on deer and antelope occurs during the fawning season before the young animals are able to fend for themselves. Researchers have observed coyotes watching female antelope hide their young fawn. When the adult walks some distance from the fawn, the coyotes approach and devour the unattended youngster.

On the one occasion I actually observed a coyote chasing an adult white-tail deer, I was unable to determine the outcome of the incident. In the southern extreme of the coyotes' range where deep snow is not a factor during much of the winter season, coyotes are not considered significant predators on healthy adult deer and antelope.

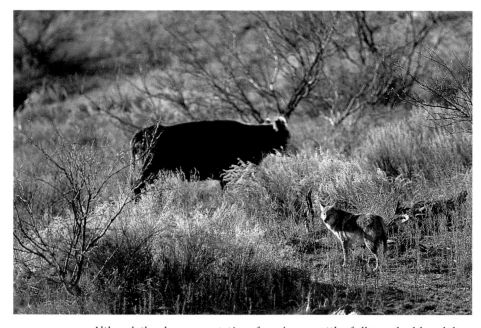

Although they have a reputation of preying on cattle of all ages, healthy adult cattle are rarely, if ever, attacked. This adult cow appears unconcerned as a coyote waits for her to pass.

24

HOME RANGE

The mesquite trees were laden with their first crop of beans in the summer of 1972 when I first heard the unusual howl. A particular coyote had initiated a travel pattern close to our home and distinguished himself from the others by a most peculiar call. Often, in the early morning hours, I would be awakened by that particular coyote yowling down the hill. At the time I was engaged in research studying the extent of coyote movement within their home ranges. A few weeks after hearing the animal for the first time I was able to capture him less than a mile from the house. After placing a numbered tag in his ear, I released him unharmed in hopes of gaining some knowledge about the extent of his hunting range in the badlands. Regrettably, I never received further data regarding the movements of this animal but many more coyotes followed, yielding information that gave insight into the hunting range of coyotes on the Texas plains.

Coyotes spend a large portion of their day on the move. Their main period of activity is early evening and early morning. During the winter they seem to be active for longer periods in the day because food is scarcer. The extent of a coyote's home range is dependent on several factors. Perhaps the most significant of these are availability of food and water as well as adequate cover. These factors play a fundamental role in determining the numbers of coyotes existing in a given area and the size of home range that coyotes utilize. Unlike the wolf, coyotes do not aggressively maintain territorial boundaries against one another outside of perhaps den sites or food caches. However, I have observed aggressive behavior toward bobcats and foxes on numerous occasions. During one of my forays in the brush during the 1970s, I was sitting atop a rocky hillside blowing on a predator call in an attempt to lure a coyote within sight of my partner, Uncle Bob. Because he had never watched a predator come to the sound of a call, I was hoping to impress him with my prowess that day. Within moments of initiating the imitation squeal of a rabbit, I spotted a large bobcat coming down a dusty trail, trotting directly to our location. Excitedly pointing to the approaching animal I quietly explained what was taking place. Suddenly, down the same trail perhaps one hundred yards behind, a coyote trotted into view, traveling with all the self-confidence one would expect from *C. latrans*. Stopping to survey the area, the bobcat had

*Once inhabited by black bear, cougar, and the plains species of gray wolf, the
canyons along the caprock of West Texas are now a favorite haunt of the coyote.
Another predator in this region, although seldom seen, is the bobcat.*

no idea that a serious adversary was closing the ranks from behind. The coyote burst into view only five yards from the big cat and froze mid-stride. Perhaps three seconds elapsed as both predators exchanged glares with one another. The bobcat, with his back arched in a most unnatural manner, suddenly bolted back down the trail. The coyote, no doubt emboldened by the abrupt departure of the cat, decided to teach the feline a lesson and immediately engaged in hot pursuit down the trail. Within moments after chasing the cat completely from our view, the coyote returned to claim the spoils. Much to his disappointment, the only goodies awaiting him were two human beings much richer for witnessing such an unusual phenomenon. Although I question whether this coyote would have actually tangled with such a large bobcat had the feline stood its ground, pairs or groups of coyotes will kill and devour bobcats if the opportunity arises.

Depending on the carrying capacity of the region, it is not unusual for several coyotes to occupy a given home range and exist harmoniously throughout the year. In the Rolling Plains, research has shown that the average home range of a coyote is about nine square miles. If the food base and safety cover are adequate, that nine square miles might support not one but possibly a dozen coyotes. Males tend to have a larger home range than females. It also appears that the home ranges of males can have considerable overlap, whereas the home ranges of females do not.

Not unlike the proverbial dog and fire hydrant connection, coyotes often urinate at strategic points throughout their home range. Research suggests that these scent posts could be methods of conveying messages to other coyotes within home-range corridors. Preferred scenting locations are along cattle trails and road systems, routes frequently traveled by all coyotes. Dominant males most often maintain the established scent posts, although subordinate animals occasionally contribute. According to some research findings, scent locations could be a way for the animals to assess population densities within an area. In such cases, high frequencies of scent posts could result in some coyotes dispersing to find new home ranges.

One incident bears mentioning that describes one particular coyote exhibiting territorial behavior, but not necessarily in a denning area. A friend of mine was working as a biologist for a large West Texas ranch near my home. Each morning he let his black labrador retrievers run through a nearby pasture. On one particular summer day the dogs were suddenly attacked by a coyote. The first thought was that the coyote might be suffering from rabies. But as the

days turned to weeks and the attacks continued, territorial behavior was the primary suspect. Running close behind the dogs, the coyote would dash in and bite the labs on the hips. Yelping with pain and surprise, the dogs would turn and engage in pursuit. Easily outrunning the over-fed pooches, the coyote would stand on a nearby hill barking, howling, and snarling. I decided to walk with the dogs for an hour or two and see if the coyote continued to exhibit the hostile behavior. Incredibly enough, the coyote continued to attack the dogs, even when I stood between the antagonists and only a few feet from the coyote. More than once I had to laugh at the plight of the clumsy dogs. Although not in any real danger of being seriously injured, their attempts at catching the spunky little coyote were futile. I was witnessing, first hand, the antics of a legend—the trickster coyote at its best, and I had the honor of a ringside seat.

The comical behavior continued long into the autumn and winter. I would often ask about the coyote and express concern for her safety because she had staked her home range within easy traveling distance of town. My fears were warranted. One day my question brought the answer I hoped would never come. She had ventured into town and was shot by a local resident after being detected rummaging through a trash can. I cherish the memories of that gutsy little coyote and am grateful for her allowing me the opportunity to observe her life, if only for a few hours.

Research conducted in Canada has revealed an interesting aspect concerning coyote behavior toward its larger cousin the wolf. In many regions of the far north coyotes and wolves share the same habitat. Although wolves normally do not tolerate any close association with coyotes, their trails do cross on occasions. Even though wolves will kill and often devour coyotes if the opportunity arises, *C. latrans* still maintains its defiant attitude, mingling a yip or two in the deep northern forests, perhaps to remind old Lobo that El coyote is alive and well. Both coyotes and wolves urinate at specific locations within home range to establish territorial boundaries. It was found that the coyote seemed to work overtime on scent post duty whenever he crossed the trail of a wolf.

The homing instinct that the coyote exhibit towards its favored range varies with individual animals. I once captured a coyote during stormy weather. Because of the heavy rains, I could not conduct my research work on the spot. Placing the animal in the cab of my vehicle, I drove several miles to a place that afforded protection from the elements. After finishing the paperwork, I released the coyote into the brush. Approximately one year later I recaptured the same

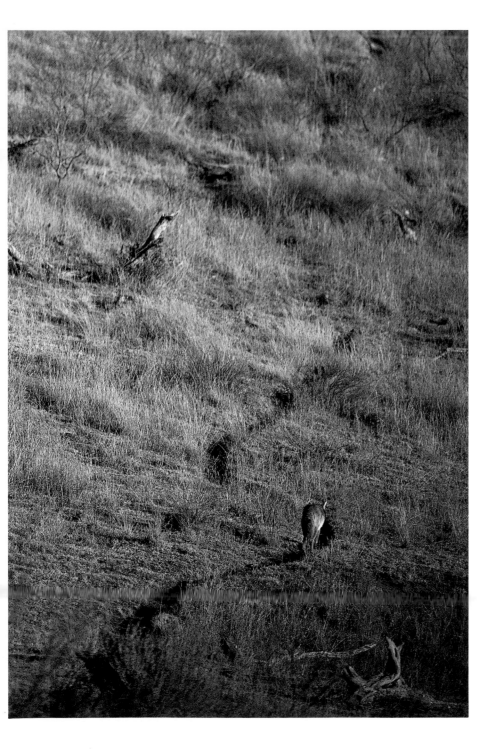

coyote within fifteen feet of the original capture point! Then, over a year later, a cowboy found the coyote dead from a gunshot wound less than a mile from the original capture site. In all likelihood, the coyote had imprinted on the area from birth. Even after having gone through the stress of having a human pull ticks, measure, weigh, and tag its ear, the coyote traveled some four miles back to the same location from which it had come. On a later occasion, I captured a female coyote and released her after engaging in the same routine as with previous animals. Approximately two years later she was recaptured in a different county over fifty miles away. Apparently, some *C. latrans* are less tolerant of human activity and move to new ranges with the slightest provocation.

Population densities within home ranges appear to vary with the seasons. During the autumn season, juvenile coyotes travel away from their den sites in search of favorable home ranges. It is at this time that large numbers of coyotes are observed along the highways, leading some people to believe that the coyote population overrides the carrying capacity of the land. In reality, these young coyotes are moving across the range checking out regions on which to settle.

Coyotes use game trails and cattle trails to traverse their hunting grounds.

If the region is already established with a healthy population of adult coyotes, the juveniles continue to move until they find an area that provides for their basic needs. Unfortunately, this is a perilous time for young coyotes as a large percentage of them die, victims of traffic along our busy highways.

Substantial variations in population densities are evident across geographical regions. In the Rolling Plains where the range is comparatively more open and contains more cultivated acreage than some regions, the coyote population is about two and a half animals per square mile. In south Texas where cover and food availability is more favorable, densities run in excess of about nine coyotes per square mile. Isolated spots within these geographical boundaries exhibit higher population densities than what the overall average might suggest.

On the Rolling Plains, especially where ranching is the predominate economic base, there is more favorable habitat for coyotes than in those areas with large tracts of cultivated land, and the population density might double or triple the suggested average for the region. Judging from the numbers of coyotes drawn to my photography blinds by cow carcasses, this isolated area within the whole region maintained a much higher population density than the accepted average of two and a half animals per square mile. On some occasions I would count as many as twelve coyotes around each of my blinds. As far as I could tell, very few animals ever fed at more than one location.

DISEASE AND INJURY

F ew sights in the wild can equal the beauty of the early morning sun glistening on the winter pelage of a healthy adult coyote. Dressed in its full winter coat, the form of a large *C. latrans* seems to radiate life and energy. Many times I have marveled at the loping gray form of this prairie wolf gliding across the grasslands and thought that few creatures exceeded the coyote in epitomizing the symbol of wildness and freedom. Even the old hunters who pioneered the southwestern wilderness spoke fondly of coyote sightings and its song as being a slice of the past that described their own lives; wild and carefree.

But not all goes well in nature, and often our perception of a Disneyland utopia for wild creatures is naive. Besides the elements of weather, food shortage, and old age, disease

and pestilence are also factors that coyotes must contend with in day-to-day existence. Not quite the good life that humans might have perceived, but the resilient coyote thrives.

The coyote leads a life brimming with pitfalls and dangers, the least of which could maim or cripple it permanently. Even the seemingly insignificant chore of running a rabbit into thorny mesquite could result in an eye injury or perhaps blindness. I have observed many coyotes in the wild that exhibit eye injuries or near blindness, some of which were caused by sharp objects such as thorns or limbs.

Few regions today offer enough remote rangeland to allow *C. latrans* the luxury of not having to cross busy highways during their home range travels. Coyotes by the thousands, young and old, fall victim to confusingly bright headlights in the night. During autumn when young coyotes are moving to new home ranges, many hundreds are killed along the highways in Texas alone.

Juvenile coyotes, ignorant to the dangers of day to day life in the brush, are often left hungry and confused during their emigration into new territory. With the possible failure of a berry crop, hunger overrides natural instinct and an attack is initiated on a slow moving porcupine. The result is slow death by starvation as the quills become imbedded in the mouth, throat, and chest.

Then, of course, coyotes are fair game for ranchers and sportsmen throughout most of the United States. In livestock-raising regions, almost everyone carries a rifle and roving coyotes are frequently targets. Unfortunately, not all individuals are excellent shots and many coyotes escape to live out their lives with crippling wounds.

Perhaps the worst of all is mother nature. Slow and insidious, nature offers an astounding portfolio of internal

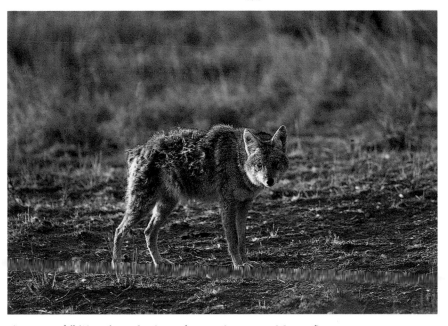

A coyote exhibiting the early signs of sarcoptic mange. Mange first appears as running sores and scabs on the tail and hindquarters. Eventually these sores and scabs will cover the entire body. Death is almost one hundred percent certain.

31

and external parasites, diseases, and pitfalls that cause a slow and lingering demise. Ticks, tapeworms, heartworms, and hookworms are but a few of the naturally occurring parasites that must be endured by canids in the wild. I have observed individual coyotes covered by hundreds of bloated ticks and so weakened by fever and anemia that they refused or simply did not have the strength to flee at the approach of a human. Weakened by the infestation of parasites, these coyotes experience a lingering end. Distemper, rabies, and parvo virus are among the diseases contracted by coyotes. Other diseases, such as tularemia, plague, and equine encephalitis are carried by the ever-present fleas.

One of the most cruel aspects of nature is exhibited by the recent outbreak of sarcoptic mange, a condition brought on by a small mite that burrows under the skin of animals and causes severe irritation and open sores. Sarcoptic mange was first observed about 1975 in the brush country of South Texas. With a dense population of coyotes in that region, the mange mite found a ready supply of hosts. Because of the coyotes tendency to travel, especially during the emigration period in autumn, the mange outbreak quickly spread. Within a three- or four-year period some seventy percent of the coyotes in this region became infected.

Symptoms of mange are obvious and rarely confused with other ailments. Hair loss and lesions are evident on the legs and hips. Within days, it spreads down the tail and forward to the head. Coyotes become preoccupied by the irritation and itch caused by the mite, and spend most of their time scratching and rubbing their bodies against trees and fence posts. Obsessed by this extreme discomfort, little energy is expended on food gathering, which sets the stage for secondary infections and starvation. Gradually a once fluffy, energetic coyote is reduced to a hairless skeleton, stumbling aimlessly across the land. Most individuals die from the condition within two to four months after the symptoms appear.

I first observed sarcoptic mange in North Texas in 1986. Approximately twenty-five percent of the population seemed to be affected during the first season. By 1994, some sixty-five to seventy-five percent of the coyote population in some areas were affected. With the colder, more inhospitable climatic conditions characteristic of this region, it is conceivable that less than one percent of the coyotes survive the infection. Studies suggest that an infection period of about fifteen years can be expected once symptoms appear in the coyote population. The infection reoccurs at intervals of approximately every thirty years.

COURTSHIP AND DENNING

Late winter on the Rolling Plains can be a time of false hopes and broken promises. Deep within the badlands, arroyos and canyons echo with the call of the canyon wren and cardinal. Roadrunners sit atop high rocky outcrops cooing their mating calls across the broken canyonlands. At fleeting intervals, it seems as if spring is finally gaining ground. But soon the withering northers come again and life comes to a standstill, shivering beneath lead-gray skies and ice-covered mesquite trees. But for those attuned to the undertones of our wild world, it is the time of transition. The late February nights soon will be filled with the howls and snarls of the coyote. Mating season has begun.

Snow, sleet, or rain do not dampen the enthusiasm with which the coyote pursues its mate. Disregarding food and sleep, dominant males accompany their mates at every step, guarding the ranks from intruding hopefuls, some of which shadow the pair's every move for days on end. For only a few days the mating ritual will dominate the life of *C. latrans*. But at its end, bonds will be made that may last several seasons, if not their lifetime, however long that may be.

Solitary during most of the year, coyotes remain in pairs from mating until the pups leave the den. Females exhibit one period of "heat" per year. Mate-pairing begins when the female experiences a physiological change called proestrus, which lasts two to three months. At this time, glands activate and excrete fluids that signal the onset of estrus. Although still weeks away from the active mating period, coyotes began to travel in pairs, rarely separating for extended periods.

When the mating period begins in middle to late February, coyotes travel constantly, stopping mostly when the female decides to do so. Howling often punctuates the evenings but takes on an almost ominous tone as snarls and growls often mingle with the yips so characteristic of previous months.

Mating is largely completed within a couple of weeks of initiation. Ovulation occurs about two to three days before the end of female receptivity. Gestation lasts approximately sixty to sixty-three days. Life resumes its normal routine until the female becomes heavy with pups in mid-April. At this time den selection becomes top priority. Unless some

reason exists such as excessive human pressure, the female will den in the same area as in past seasons, sometimes even reusing the same den from seasons past. Coyotes select a variety of locales and shelters in which to raise their young. Enlarged badger burrows, excavated overhangs, or natural rock shelters make excellent coyote dens. The site usually has access to a sunning area that offers a view of surrounding terrain. The adults are often seen in these spots relaxing or watching for danger. Sites can be on hilly terrain or flat prairie land. In agricultural areas, dens are often located in fence rows where soil banks have been raised through erosion or by other causes.

On average, the dens are about thirty-six inches in depth. Overall length runs about nine to eleven feet. If excavation allows, I have observed dens with nursing quarters or enlarged rooms with side tunnels to accommodate the young whelps.

Pups are born from late April through May with late breeders, common among first litter females, whelping as late as June. Litter size varies across the coyote's range. In the northern perimeters where population densities tend to be lower than the southern ranges, litter sizes are generally larger. One report documented nineteen whelps observed in one den. In the southern ranges, where overall popula-

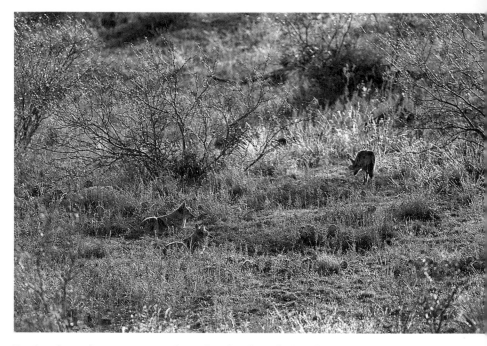

During the mating season, attentive males often forgo feeding for days as they watch the females every movement.

tion densities tend to be higher, litter sizes decrease. The largest litter that I have know of had eleven pups. The average litter size in the Rolling Plains of Texas is about five pups per den.

Coyote populations are density dependent, meaning that the coyotes themselves regulate the population within a given range. Female coyotes possess a physiological trait that allows the production of larger litters when environmental

conditions prove favorable. For example, in areas where jackrabbit populations maintain a high density, litter sizes increase in coyotes. When conditions deteriorate or coyote densities have reached maximum levels for a given area, litter sizes will decrease. Fetus reabsorption, resulting in smaller litters, can occur when disease or food shortages inflict excessive stress on the adults. Research suggests that ovulation and pregnancy is adversely affected when females develop symptoms of advanced sarcoptic mange.

During my study of denning habits in the Rolling Plains of Texas, many days were spent riding horseback through the badlands searching out dens and excavating pups for research data. Coyotes are easily disturbed by human activity around their den sites and will move the pups if they detect any human presence.

The days were usually warm and pleasant when I saddled up to began my search. Striking out through the mesquite and tabosa grass flats, my main interest lay in the silt and clay badlands where tracking was somewhat easier. With billowing spring clouds above and the aroma of spring flowers in the warm breeze, I traveled leisurely along until my route crossed a trail well worn by coyote tracks. Coyote traveling activities are subdued in the denning season, so when a well-used coyote trail appeared I knew that a den

was only a short distance away. Backtracking along the trail usually led to extremely rough areas where holes and crevices were outnumbered only by the mesquite and junipers growing there. Once the tracks became so innumerable that it was obvious the den was only a few yards distance, I began searching on foot, leaving my horse tethered to a tree limb. More than once my search ended with the discovery of five or six pups sleeping in the shade of a cutbank. Upon my approach, they would scurry to the safety of the den and remain there until I removed them for tagging and weighing. After investigating around the den site, it was evident that young coyotes are much like young children in that they have no concept of how to maintain a tidy home. Bones, sticks, droppings, and flies are telltale signs of a den occupied by a litter of energetic coyote pups.

Prior to initiating my research on coyote behavior, I was fortunate to locate a den site that was somewhat of a step back into the pages of history. The Rolling Plains were range to the great southern buffalo herds until their demise in 1879. Although their trails have long eroded into oblivion, an occasional skull or bone can still be found, protruding from a creek bank or canyon wall where flood waters carried it over a century ago. Little wind stirred the buffalo grass on that spring day in 1969 as a companion and I made

35

our way from the grassy escarpment into the eroded canyon. Walking up the creek we began to notice an abundance of coyote tracks leading up and down the creek bed. Momentarily we saw the telling sign of a coyote den that included dung, flies, bones, and a loafing site. The den had been excavated directly into the creek bank, but about six feet or more above flood line. Peering into the hole I could not see pups but knew that they were inside because of the signs present. Soon I began to study the bones lying about and remarked that something wasn't normal about their appearance. They appeared too old to be recently scavenged. After poking about we soon saw the ends of other bones protruding from the ground and, after some excavation, unearthed a bison skull only a few feet from the den entrance. Those coyote pups had been chewing on the remains of a bison skeleton that was well over a century old! In all likelihood, the last predators to have fed on that carcass were the now extinct plains buffalo wolf.

Whelps are born blind and helpless. At about ten days of age their eyes open. The young are nursed by the mother and begin taking solid food at about three weeks of age. By four weeks, they are moving about the den site and investigating the immediate area. Males contribute to the care of both the nursing mother and young pups by providing some food. At first, the pups feed on small items such as grasshoppers and mice. They remain within the den area until about August. By this time, they have begun to embark on short hunts that may carry them a half mile or so from the den. Also, family groups including adults can be observed traveling together in the late evening or early morning hours. At twelve weeks of age the average juvenile weighs about twelve to fourteen pounds. By sixteen to eighteen weeks of age they have started to break from the family unit and launch into their search for a home range in which to settle. If the local coyote population is growing, the juveniles may establish their homes near the den. If the population is at a maximum level, then emigration to other regions is in order.

I recall one den in particular that harbored seven tiny pups weighing one and a quarter pounds each. These squirming little fuzzballs were less than ten days of age when I found them. The adults had converted an old badger den into a spacious, comfortable home featuring a nursing room and additional side chambers for the pups. After taking my usual notes including external parasites, weight, body condition, and tag number, I returned them to the den and rode away. The following day I returned to note whether the adults had moved the pups in the night.

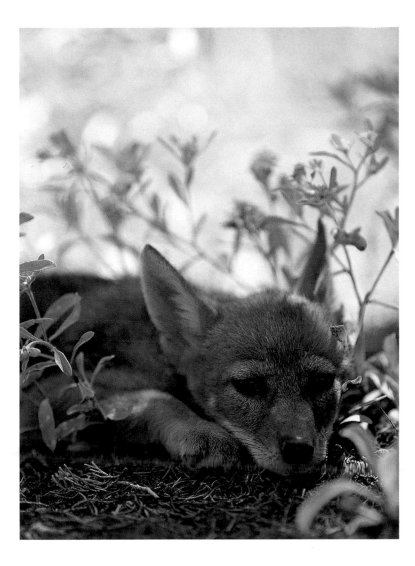

An eight-week-old pup.

They were indeed gone. Six months later I recaptured one of the pups only one mile from the den site. He had gained over twenty pounds and was in excellent condition. After retagging and releasing him once more, I never saw the coyote again. Apparently two sessions with a researcher were too much to handle and he wisely skipped the country.

Besides being harassed by researchers, life in a coyote den is not one of complete safety and comfort. Disease and parasites thrive in these close quarters, increasing the likelihood of high attrition rates in young pups. Dark and dank, a coyote den is a thriving buffet for flies, fleas, and ticks. A few internal parasites such as the hookworm can cross the placental barrier and infect the litter. Anemia resulting from heavy infestations of this common parasite weakens the pups and can cause death. Parvo virus, a deadly infection that can ravage denning coyotes, always looms as a threat. With the adults off on daily forays for food, even the slow moving badger will sometimes raid a litter of pups, devouring them in rapid succession before the return of the parents. Cougars are also known to prey on pups.

POPULATION DYNAMICS

An old pioneer and buffalo hunter once said that he witnessed a pack of coyotes on the Rolling Plains of Texas that numbered some three hundred animals. Such a sight would stagger the imagination if not create national attention if seen today. But no doubt, when thousands of bison carcasses lured predators from all corners of the plains, sights of enormous groups of predators were apparently not uncommon. Although the likelihood of seeing such incredible numbers of predators went out with the implementation of strychnine during the late nineteenth century, many regions in the West and Southwest harbor high concentrations of coyotes from time to time.

In the more temperate regions of South Texas, an abundance of food coupled with favorable habitat support high population densities of coyotes. Historically, this region has been known for coyote densities to hover around nine coyotes per square mile, an incredible density compared to the northern reaches where about two and a half animals per square mile is the average. In the far northern latitudes of their range, where food and climatic conditions severely restrict animal numbers, coyote densities are sparse indeed.

Conditions occur in some areas of the coyotes' range that enhance the carrying capacity of that region for a short period of time during the year. For example, in many regions ranching practices have experienced a gradual transition from the traditional cow-calf operation to stocker programs. In a stocker operation, large numbers of yearling cattle are grazed on wheat fields during the fall and winter seasons. This short-term grazing practice allows ranches to support many times over the normal carrying capacity of the range. A ranch that normally runs one thousand cows and calves could support ten thousand yearlings for a short period. Cattle numbers of this magnitude rival, on a small scale, the scenario from the late nineteenth century when the bison roamed these very same prairies. With only a one percent death loss on this number of cattle, the available beef for coyote consumption would approach fifteen tons! Such a large quantity of prime meat is an irresistible lure for coyotes from all corners of the region. Under these conditions and the fact that predator control activities are minimal on most cattle ranges, coyote population densities can double the normal average during the height of the cattle grazing season. Once the cattle are removed from the ranges, coyote

numbers dwindle to normal levels.

The dynamics of coyote populations can be determined by the known age distribution of sample animals taken from an area. Where predator control efforts are minimal, coyotes have a life expectancy of the average domestic dog. I have aged a number of coyotes whose incisor wear indicated an approximate age of twelve yeas. Most of these individuals were healthy and could expect to live for several more years. When populations are stable within a region, the average age of animals include mostly mature adults in the four- to six-year-old range. If population levels are reduced by factors such as disease or control efforts, the average age of coyotes tends to be much younger. In this case, juvenile animals from surrounding areas emigrate into those voids. The mobility of *C. latrans* ensures that favorable habitats will always echo with the cry of the coyote.

VOCALIZING

Some of my fondest early memories are of summer nights spent sleeping out in the yard with my brother and Dad on old cots purchased at the nearest army surplus store some twenty miles away. Our home, located atop a hill above the flood plain of the Brazos River, was a simple ranch house with a spacious yard. A cool breeze was always present during the summer nights, and we relished the opportunity to lie awake on our cots and marvel at the constellations so brilliantly displayed in their heavenly theater far above.

But the Milky Way was only one of the treats that awaited us as twilight gave way to night. Long after the nighthawks ceased their aerobatic pursuit of mosquitoes and moths, and sometimes after sleep had overtaken us all, the brush would finally give up those creatures who hunted under the shadow of darkness. Rabbits, feeling safe under the veil of night, hopped around the perimeters of the yard feeding on the lush vegetation. The rustle of weeds betrayed the movement of a clumsy opossum looking for a nest of hapless brush mice. Sometimes the excited yip of our dog, old Wheezer, would awaken me and I would lie wide-eyed as he made a futile dash after a fleet-footed cottontail. The poorwills, screech owls, and mockingbirds were all elements of the nightly symphony I remember so well. But the orchestra was never complete without the call of the coyotes just before dawn.

The howl of the coyote has long been a symbol of the boundless freedom that characterizes the remote lands of the Great Plains and the West. Perhaps when their range was restricted to the lands west of the Mississippi River, such lyrics as "bury me not on the lone prairie, where the coyotes howl and the wind blows free," lent a more western if not primitive theme to the verses. But now, with the coyotes' range extending from the Atlantic to the Pacific, even echoing from the streets and trash cans of Los Angeles or the Bronx, the wail of the coyote might not carry the significance it once did in the early twentieth century. Still, in modern day America, few people will deny that the yip of *C. latrans* over a dying campfire is cause for a nervous glance into the darkness, perhaps a primeval reminder that in only a blink of geologic time our ancestors sat likewise, waiting out the night as the coyote and his ancient canine cousins competed directly with human existence.

The yelping of coyotes around our Texas badlands home was always a special treat. In addition to the wolf-like howl so epitomized in the movies were yips and growls and group howls—often heard at the onset of weather change. All sounds were mentally recorded and categorized in de-

A coyote alerts to an intruder. Barking at intruders normally occurs around den sites.

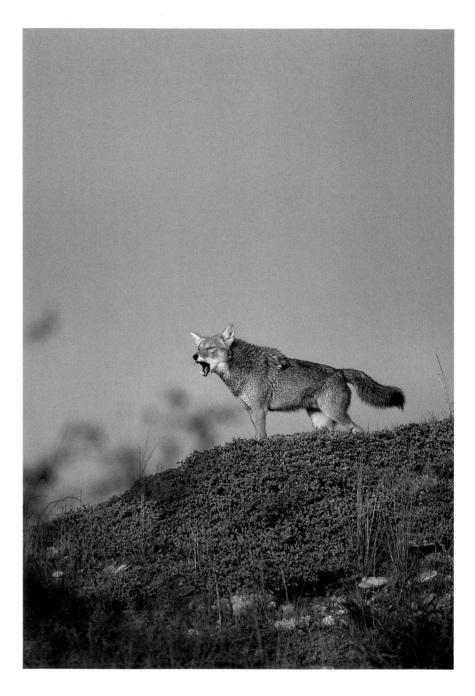

scending order of preference. Personally, I was always fond of the so called "wolf howl," usually emitted by the adult males. But I listened with interest to any and all that flowed into the evening sky.

The adult coyote auditory repertoire consists of about eleven vocalizations. Some overlapping occurs, making exact patterning difficult at best. Data collected in one region may not apply to other areas of the coyotes' extensive range. But *C. latrans* does have a variety of voices that are applied on various occasions, and the mixing that is exhibited would make a high-tech recording studio listen with attentive envy.

Vocalization is an important means of communication between coyotes. The vocalizations include several variations of expressing antagonism toward one another such as woofs, growls, and huffs. For greeting one another a "wow-oo-wow" might be the preferred sound. Or, if two individuals have been separated and suddenly find one another a group howl is often emitted. This includes both animals howling simultaneously but on a different frequency. Some scientist theorize that coyotes may use their howling as a means of regulating population densities within a given area. For example, the amount of howling in an area could be a auditory warning for other coyotes to bypass that loca-

tion because of the numbers of animals already existing there. The amount of howling present in the springtime might have a physiological effect on breeding females, subsequently causing a reduction in litter size by possible fetus reabsorption.

In the many years spent working with coyotes, I have had the opportunity to be both observer and target of vocalizing coyotes. On one occasion I was using an artificial mouth-call in an attempt to lure coyotes into open view. My companion and I were seated on a high hill that protruded above the surrounding landscape, giving an excellent view over several thousand acres of rangeland. After a few moments of using the mouth-call we were greeted with a wonderful display of yip-howls that seemed to trail off into a series of gargles and laughs. Within a few moments I was astonished to see nine coyotes dashing our way from the river bottom below. The lead coyote appeared to be a female. Considering that the season was late winter and in the waning days of the mating season, the majority of the group could have been males attempting to win the favors of the female. When they were bombarded with the imitated sounds of a squeeking rodent, the female decided to investigate and the remaining coyotes followed suit. On another occasion I had a similar incident occur in the autumn. This time, twelve

coyotes came to my location. Instead of coming in a group they approached in singles or pairs and no vocalization occurred prior to their movement.

A pattern seems to exist that indicates vocalization occurs prior to or immediately after the passing of weather systems. Sigmund A. Lavine wrote that rural people of the plains often depend on the wailing of coyotes to signal the change of weather. Without fail, each year I note the occurrence of lone howls or yip-howls just after the passing of rain storms. On one occasion I had the pleasant experience of standing on a hilltop at midnight, having spent the past several hours chasing and photographing a particularly strong thunderstorm over a hundred miles of Texas plains. The storm, having passed my location and rushed eastward, left a trail of broken clouds directly above. To the south a few miles, serpentine forks of lightening continued to dance about the darkened landscape. Soon the broken clouds revealed the rise of a full moon. Distant hills began to take shape in the illuminating moonlight as I stood with camera in hand absorbing the energy of the moment. Then, quite near, but in the shadows of the mesquite, a single coyote began a long, lingering howl. Soon, a short distance away, an answering howl coursed into the night. Within moments, several animals joined into the fray until the entire countryside reverberated with their calls. The dying storm, a full moon, and the call of America's most primitive canine in the midnight hour—indeed it was a moment to savor.

SOCIALIZING

Shuddering beneath a thick layer of clothing, I turned my face away from the bitter December wind sweeping across the barren hilltop where I lay. Clutching a camera and heavy lens in one hand and inching myself along the rough terrain with the other, I thought of the words spoken by an old buffalo hunter who hunted this region over a century ago. He too cursed the weather and spoke of the unpredictable climate of the plains—warm one day and a blizzard the next. As the bluestem grass leaned sharply into the south, another gust of wind covered my camera and 500 MM lens in a fine layer of sandy grit.

Twenty yards further I could see the mesquite-wood blind I had constructed a few days before. Appearing as a natural formation on the horizon, the coyotes had accepted its presence after four or five days of close scrutiny. In

hopes of getting some great photos of coyote socialization and interaction, I had placed a dead cow some thirty yards distance. Using the cold wind to my advantage, I painstakingly crawled to the door of the blind and entered. I peered discreetly over the log breastwork and thrilled at the sight before me. Seven or eight coyotes stood around the bait, and another four or five lurked in the brush beyond.

Unlike the wolf, *Canis latrans* does not maintain close family ties over extended periods of time. After the denning season ceases in late August, family groups begin to break up. The juveniles hunt on their own and eventually leave the den site to establish their own home range. Hunting in singles or sometimes in pairs, they live out their lives rather independently, combining in small packs principally in the mating season or at food caches throughout the winter season.

Although loners by nature, coyotes must communicate with other coyotes. The most obvious method is by howling whenever distance separates individual animals. Once together, whether on baits or otherwise, grunts, growls, and body language are the principle methods of conveying various intentions.

Like the wolf and domestic dogs, coyotes establish a pecking order within the family unit early in life. Behaviorally coyotes show higher levels of aggression earlier in life than either wolves or dogs. Pups tug and rear over subordinate siblings, establishing the order of dominance only a matter of weeks after birth. Once coyotes attain adulthood, a pecking order still exists between individuals, and is displayed prominently whenever two or more coyotes chance to meet.

"Tippy" came to my bait station one cold, clear day. He was a mature coyote bordering on old age, identifiable by a large white tip on his tail and a split right ear. His ranking in the

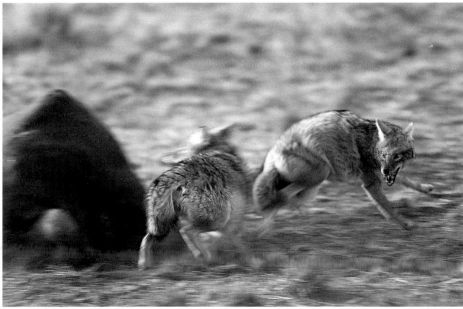

There is constant displacement of animals around food caches. Fights break out and a new order is established. The subordinate animal has its tail tucked under its belly.

43

dominance hierarchy was undoubtedly high, I guessed, because he was almost bold in the face of the whirring motor-drive only thirty yards away. Tippy, as well as other dominant individuals, rarely showed themselves at a station until the bait was well ripened and opened for easy access. At this point, animals came from all points of the compass, sizing each other up and sometimes engaging in battle, impressing the more submissive coyotes with scary faces and growls.

Whenever two or more coyotes meet, it is rare that one is equal to the other in the hierarchical order. Body language is the means of communication and questions concerning top-dog status are quickly apparent. During my months of observation, it appeared that mature adult males dominated the colorful arena of characters around the baits. Younger animals, whether male or female, shied easily as the dominate animals approached, exhibiting menacing glares and mouth threats. A common facial threat is achieved by opening the mouth, exhibiting bared teeth, and leaving the ears standing partially erect. The subordinate animals would skulk away tucking their tails between their legs and would lie down in the shade of a mesquite within easy access of the food source.

During the months of my observation period, I watched and photographed coyotes grin, gape, and threaten their way to and from a meal. Sometimes, when two dominant adults met, a quick but decisive battle ensued. The loser would dash off to the side and lie down. But if the combatants proved to be near matched in size and aggressiveness, successive fights reoccurred during a span of only an hour or so.

On one particular morning I was thrilled at the sight of about twelve coyotes stalking around the ripened carcass. To my delight, I spotted Tippy slowly threading his way toward the group. Several coyotes gave ground at his approach. For a coyote, Tippy used relatively good eating manners. Picking a morsel here and there, he took his time in selecting the choicest meat.

Within a few minutes, I spotted movement to my left. Appearing from out of a shallow draw, another large male coyote trotted toward the crowd. I knew from first glance that trouble was brewing. From seventy-five yards out the big male initiated an aggressive gaping mouth threat. With tail and head outstretched, "Wag" hardly slowed his pace as he approached Tippy. Tippy met the challenge without hesitation and dust boiled as they reared and fought. Shortly, Wag, the intruder, had had enough and backed away from the scene. For the following hour however, both coyotes challenged one another and both gave ground on a

near equal basis.

On occasions I observed yearling coyotes that exhibited dominant qualities even when interacting with the mature adults. Time and again I recognized one young coyote return repeatedly after being rushed by the dominant adult. Although bitten and bumped, the smaller coyote would continue to harass the threatening adults with his presence, even diving in occasionally for a quick bite. I admired his tenacity in that he would stand his ground around such imposing characters as Wag and Tippy.

During aggressive behavior, dominant pups and adults approach one another with a stiff-legged gait, the ears forward and upright, the fur on the back is erect, the tail is held at about a forty-five degree angle, and they frequently snarl and expose their teeth (grinning). Subordinate animals respond by exhibiting submissive behavior including flight, avoidance, rolling over to expose the stomach, grinning, urinating, and whining. Other examples of submissive behavior include walking in a low crouch with the tail tucked between the legs and head held low, or licking the face of the dominant animal.

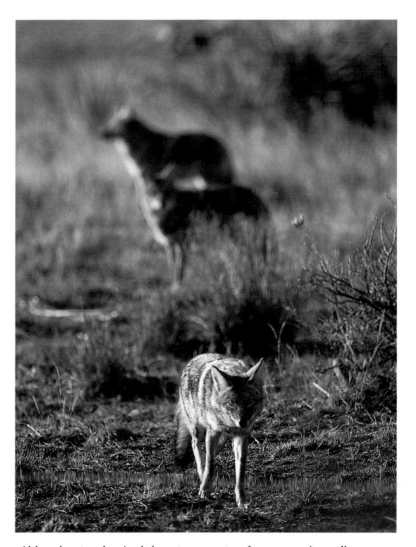

45

Although not pack animals by nature, coyotes often are seen in small groups during the mating season. These groups usually consist of a dominant male followed by a group of younger males as they follow an ovulating female.

EPILOGUE

October is a time of celebration across the plains, for rarely is such energy and anticipation manifested in the actions of the wild ones. The waterfowl migration is in full swing along the Central Flyway and the autumn movement begins for coyotes, in search for new home ranges. It is my favorite time to explore and experience the transition of the living, for everywhere life is in motion, creating an aura of magic and wonder in a colorful land.

🐾

The coyotes had not yet discovered my presence as they hustled about, busily chewing on bones and digging exploratory holes in the dry creek bed. Obviously a family unit, I was surprised to see them still together this late in the season. All appeared to be siblings as body size was uniform throughout the group. As I took several photographs, the late October sun cast its glimmering rays across the animals, illuminating their coats with a rich golden hue. Finally growing suspicious of the whining motordrive, the coyotes began drifting, one by one, into the darkening landscape.

A single animal continued to linger for awhile and soon began to move in my direction. Feeling certain that my cover was blown, I was perplexed to see him approach within a few feet downwind, and then amble back to the creek. Taking my chances, I rose to a crouch and slowly threaded my way through the feather dalea and yucca to the creek bottom. Hardly giving me a glance, the coyote began digging in the soft sand while I worked the camera in the failing light. Twilight soon edged its way into the sky and I watched in silent reverence as the form of the coyote began to merge with the land. Finally, he began slowly moving away, drifting through the brush in ghostly relief. I tried to follow as best I could but my clumsy attempt seemed foolish in the quiet solitude of late evening. Night was fast approaching when I saw him for the last time. Thinking I had finally alarmed him with my footsteps, I was amazed to see him quietly reappear nearby. His form was almost transparent, drifting in and around the trees until he was a part of the night.

It was a time that I try to always remember; those few minutes with that trusting coyote. In all the years spent working closely with this creature, no other encounters

could quite match the connection I seemed to have with that animal. Was his nonchalance to my presence a factor of youthful innocence? Or did he indeed realize I meant no harm and ultimately honored me with an intimate glimpse into his world?

Coyotes have fascinated humans longer than written history. Native Americans celebrate this species' existence in legend and myth, appreciating it for the creature that it is; a free spirit and resilient survivor. Revered and hated, persecuted and studied, the coyote is an animal whose time has come. Our appreciation for this creature is already evident through a guarded respect now recognized throughout America. The interest in the health of our lands and its fauna continues to be of national concern. As we launch into the twenty-first century, perhaps this tenacious creature will come to be accepted as the legendary survivor that it is.

At one time deer, buffalo, wild turkeys, and wolves roamed the Canadian Breaks of the Texas Panhandle. The howling of wolves and thundering hoofbeats of buffalo have been replaced by coyotes and cattle.

Dressed in full winter pelage, a young male peers through yuccas in the badlands of North Texas.

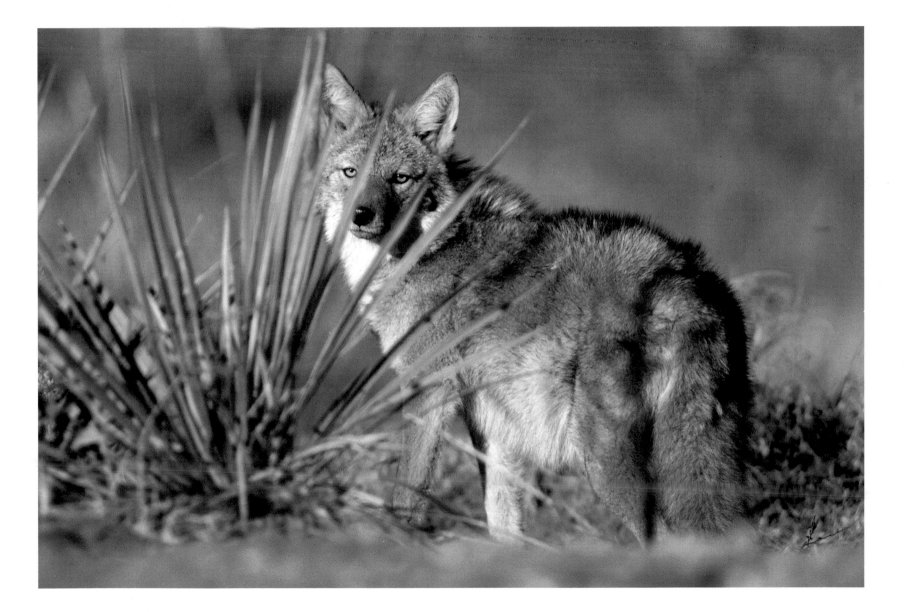

49

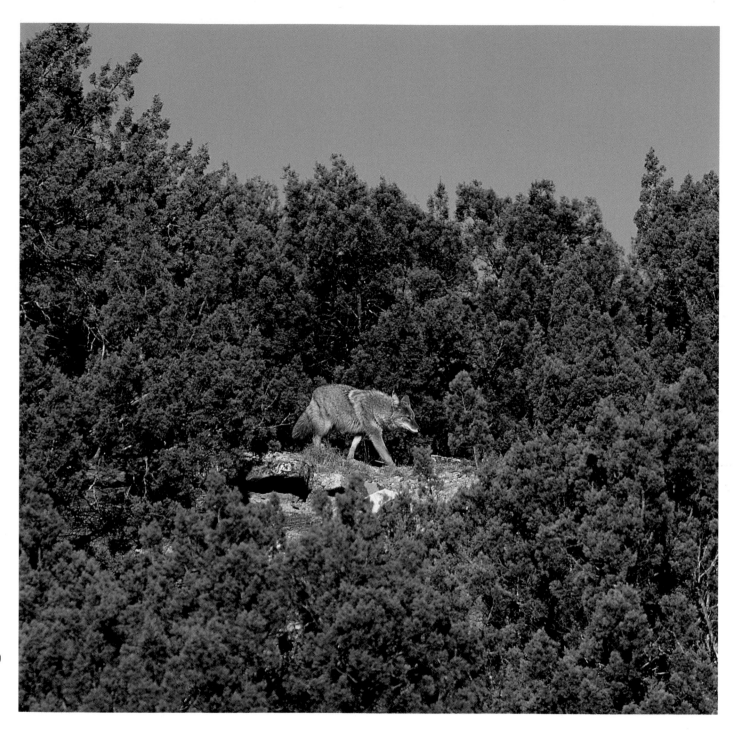

Cedar thickets offer excellent hunting opportunities.

On early winter mornings coyotes frequently sunbathe on east-facing hillsides using shrubs as a windbreak.

50

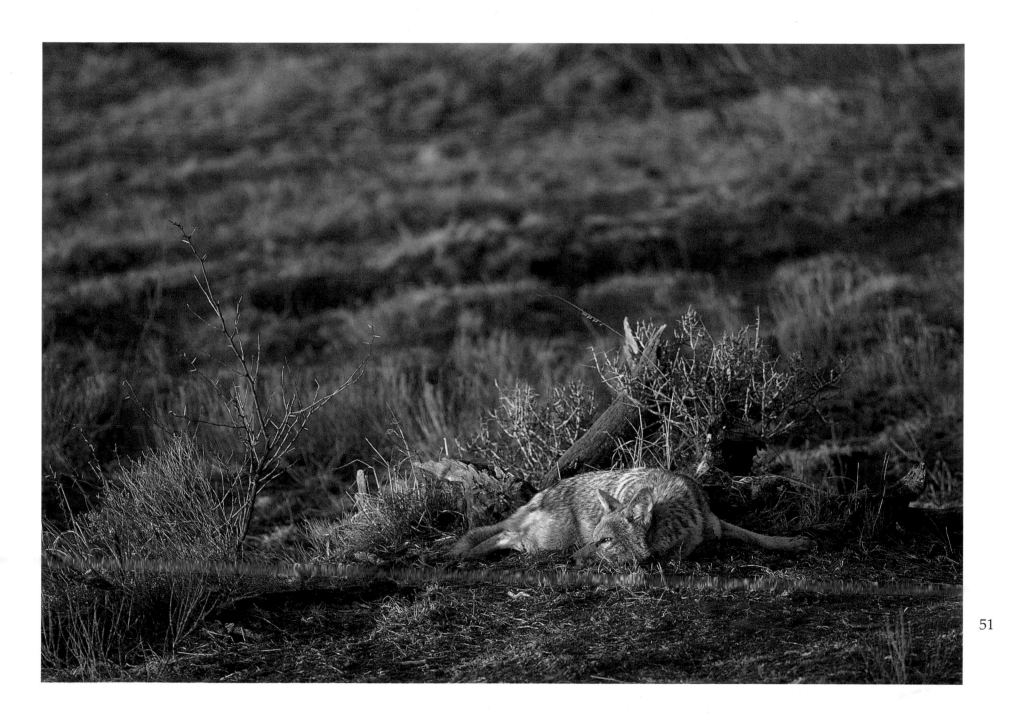

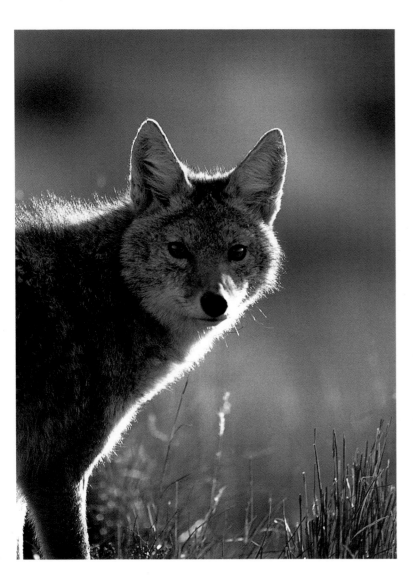

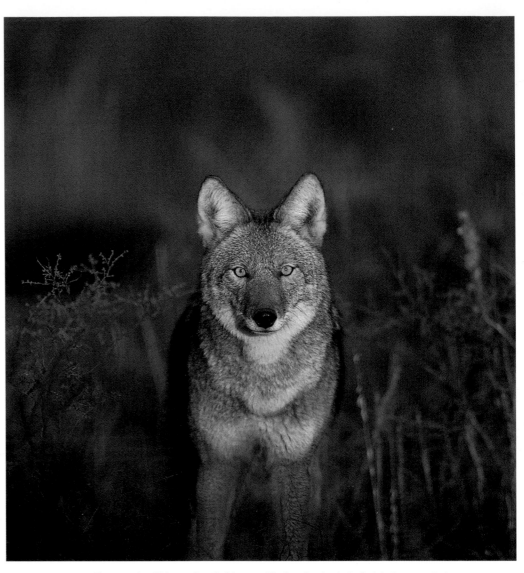

Six-month-old juveniles (left) resemble females in their facial characteristics. Adult females (opposite) are somewhat smaller in overall size than males and have a narrower and more pointed muzzle. Adult males (above) are characterized by a broader forehead and muzzle. This male is in his prime, probably five to seven years old.

52

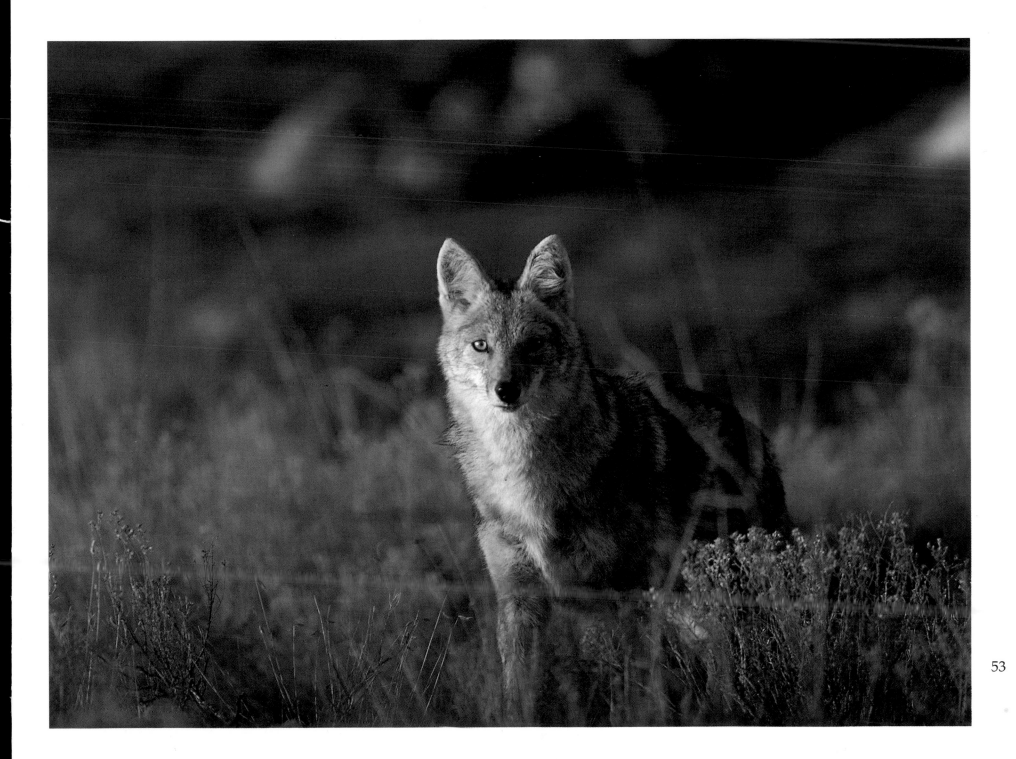

53

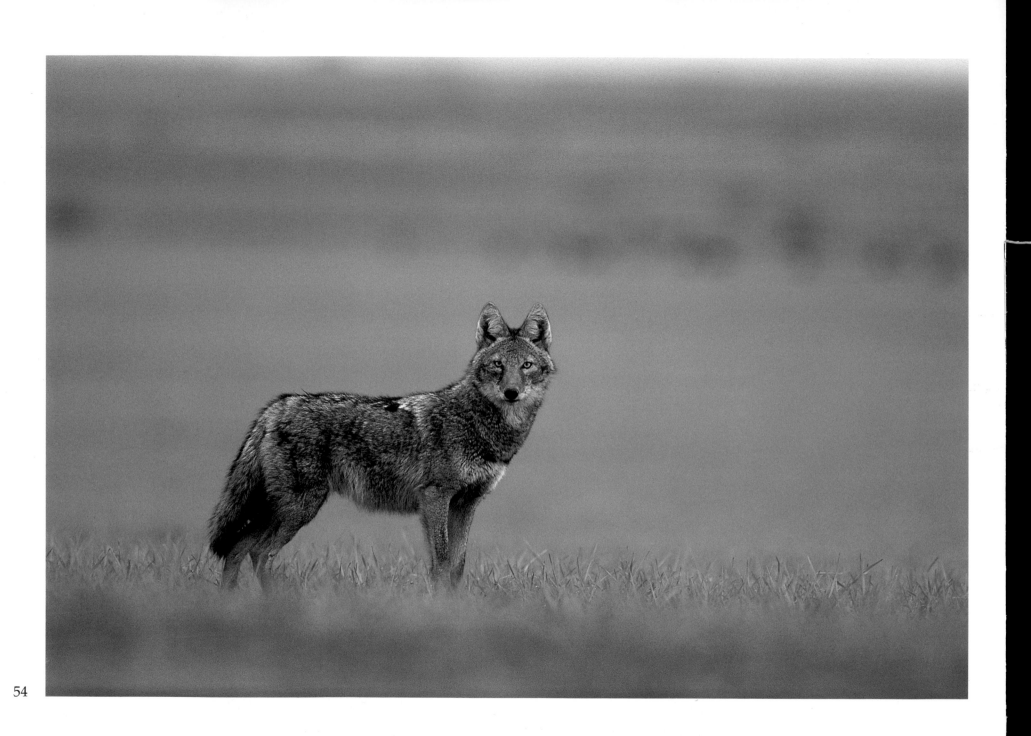

Coyotes spend a considerable
portion of their day on the move.
They tend to be most active
around dusk and dawn, but can
be seen at any time.

The eastern plains of New Mexico
have always been home to the
coyote.

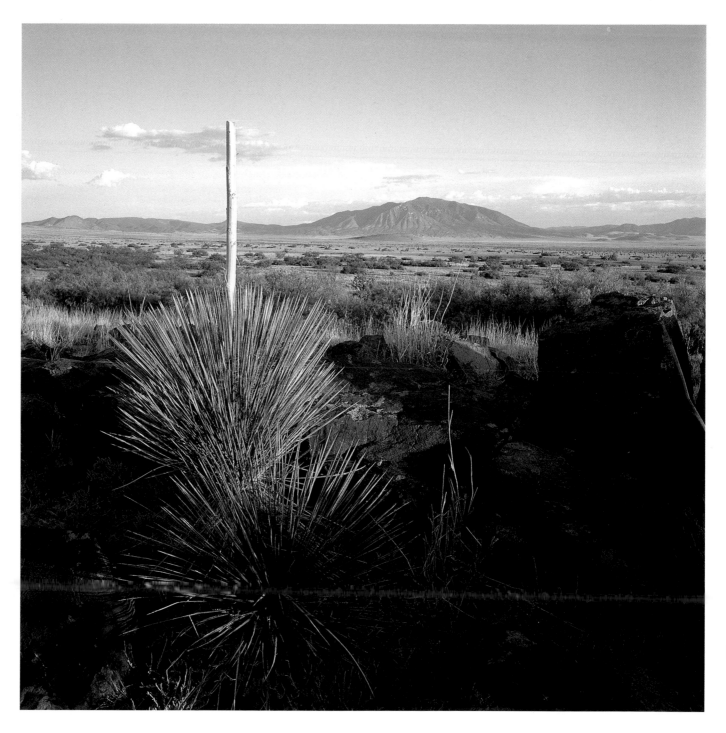

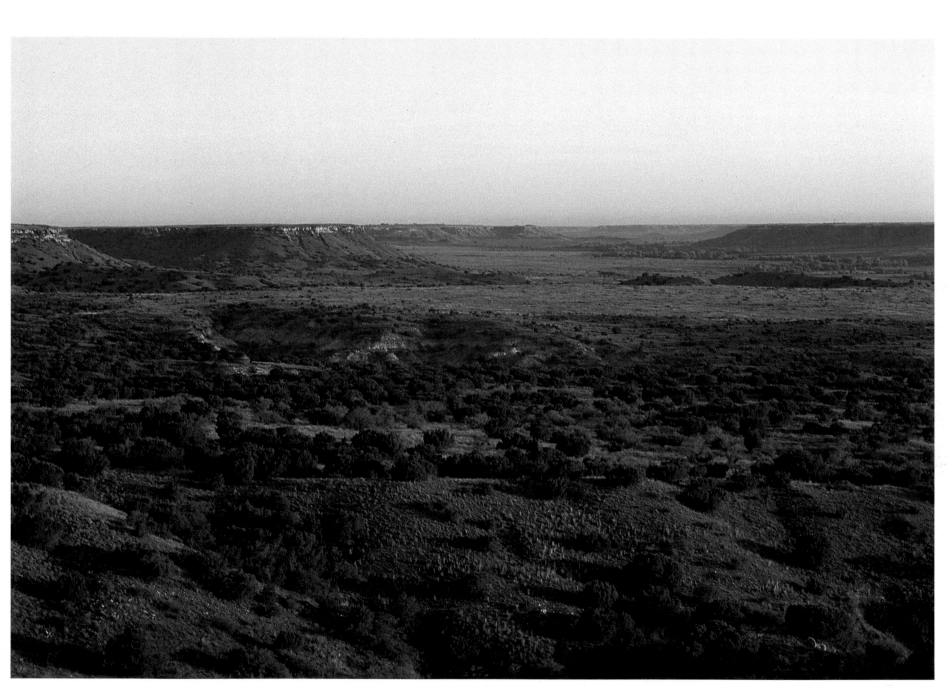

The escarpment delineates the High Plains from the Rolling Plains of Texas.

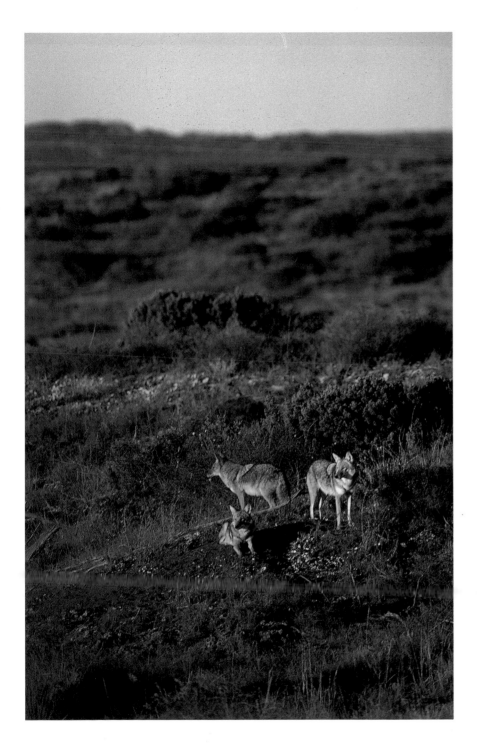

Normally a solitary animal, occasionally groups of coyotes will gather. These three coyotes are lounging on a hillside in the North Texas badlands.

The hearing of these canids is extremely acute. The animals could hear my camera shutter click as far as two hundred yards away.

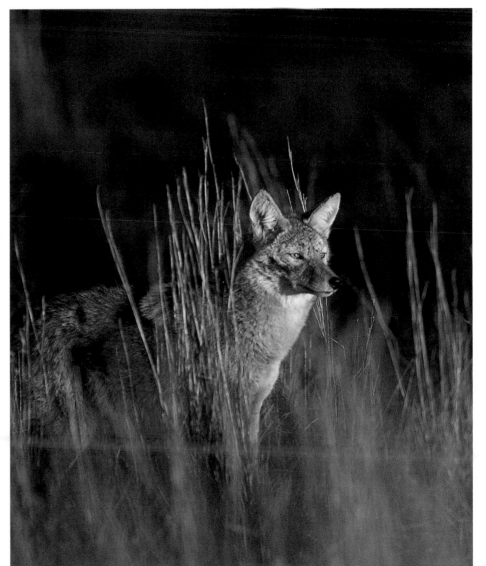

Carrion is a primary food source in late winter, which is the most stressful time of year for animals living on the High Plains. Coyotes will often return to chew on the bleached bones of an old carcass.

Coyotes are territorial in close proximity to den sites and will attack other predators or canines that approach. Although they will not attack people who approach a den, they are easily displaced from their den by human activity.

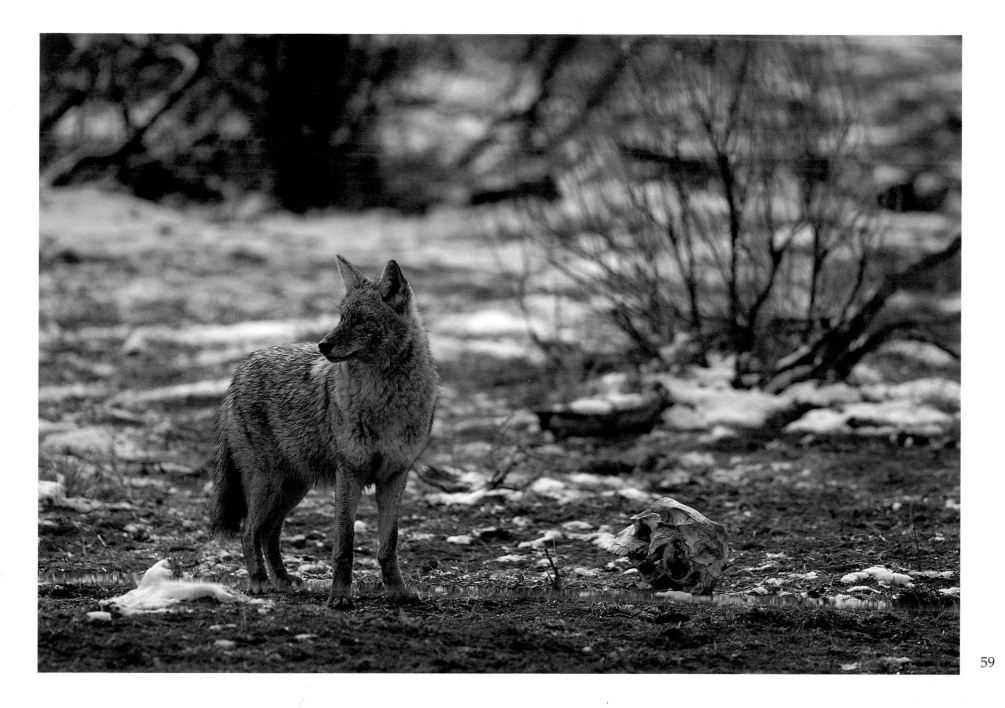

The coyote coexists with humans on the heavily cultivated Texas High Plains. As the land became more cultivated the coyotes adapted by using these draws to traverse their hunting range.

Coyotes are the most vocal of all the canids and possess about a dozen different vocalizations. The name Canis latrans *means "barking dog."*

Dramatic light bathes the northern Texas plains.

The coyote's coloring affords natural camouflage. These coyotes are difficult to detect in the tall grass.

Coyotes tend to prey on jackrabbits and rodents only after food items that are easily available, such as mequite beans, become scarce, either during a crop failure or in the winter.

Normally coyotes do not prey on healthy adult sandhill cranes. However, the ever opportunistic coyote is always on the lookout for a wounded or diseased bird.

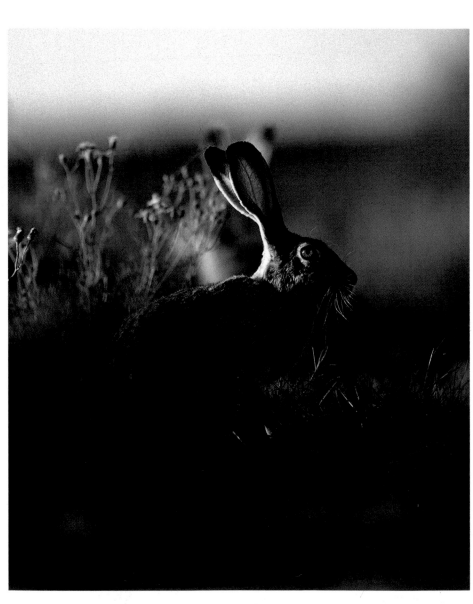

64

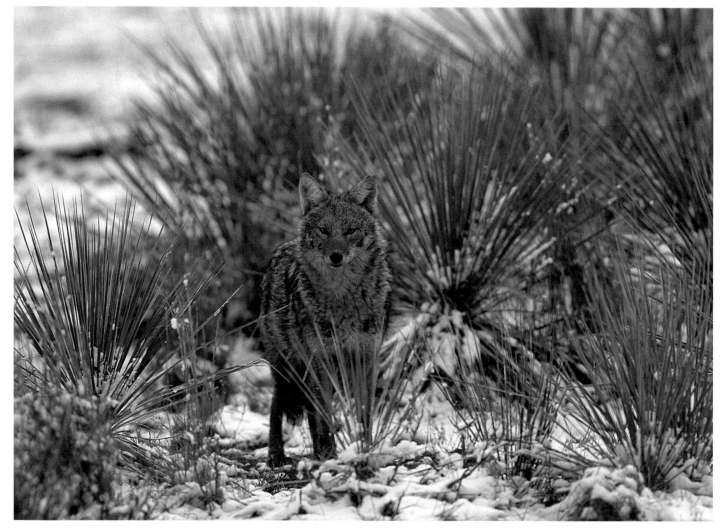

Late winter presents the most stressful conditions for coyotes. Vegetation food sources are depleted and coyotes must rely almost exclusively on capturing rodents and rabbits, which requires a higher energy expense when they have little to spare. During this time they also will feed on carcasses or as a last resort, prey to a limited extent on livestock.

The coyote has played an integral role in the lives of Native Americans. These petroglyphs of a coyote and jackrabbit were drawn about eight hundred years ago by a hunter-gatherer band that inhabited the eastern plains of New Mexico.

By midsummer a coyote's diet includes a high percentage of readily available grasshoppers and cicadas.

Coyotes are more apt to be seen scavenging on dead cattle than attacking live ones.

Coyotes have a deserved reputation for preying on sheep. In lieu of poisons or trapping that kill indiscriminately, donkeys have proven to be an effective deterrent to coyote predation. Other methods include using dogs or llamas to stay with the flocks.

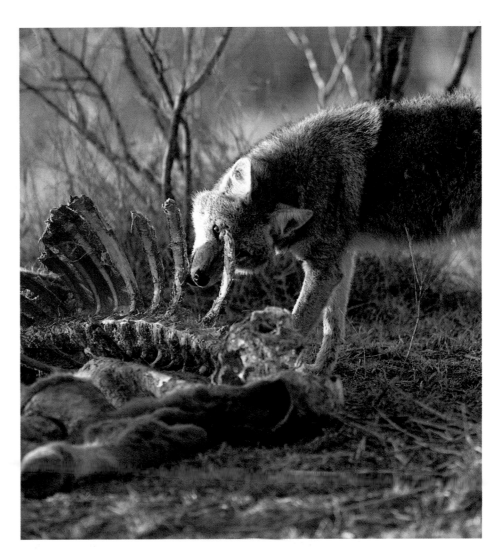

69

Coyotes frequent calving grounds to seek afterbirth and the rich mature from the young calves. Although they will kill a young calf occasionally, they are more apt to snip its tail. Individuals who are accustomed to dining on calves tails can become a nusiance and will be eliminated by the rancher.

After about three days of investigating a carcass, the coyotes would begin to feed. Once they did, a 550-pound carcass would be stripped clean within four days. Each carcass was visited by approximately twenty-five individuals.

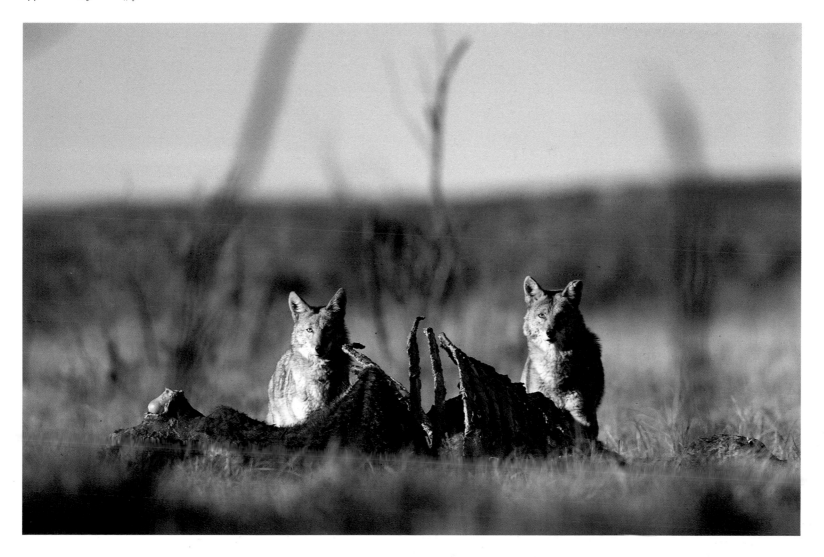

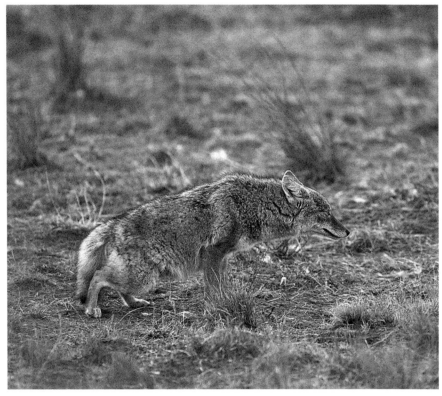

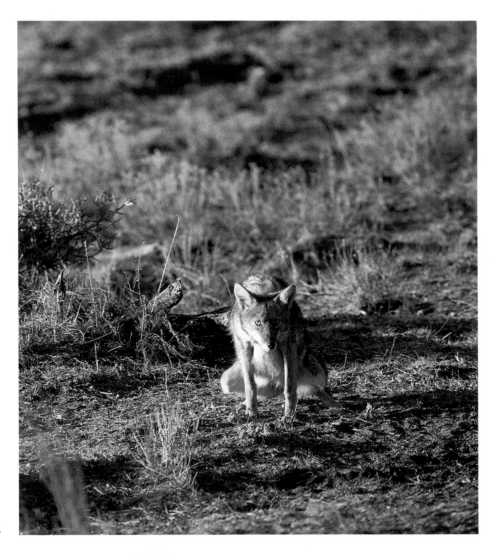

Like domestic dogs and wolves, male coyotes (opposite) establish scent posts. When a scent post is encountered, the male will often rub his face on it, roll on it, and then urinate on it, leaving his mark behind. Young males (above) generally do not establish scent posts. Females (left) may establish scent posts during estrous or when her territory has been invaded by other coyotes.

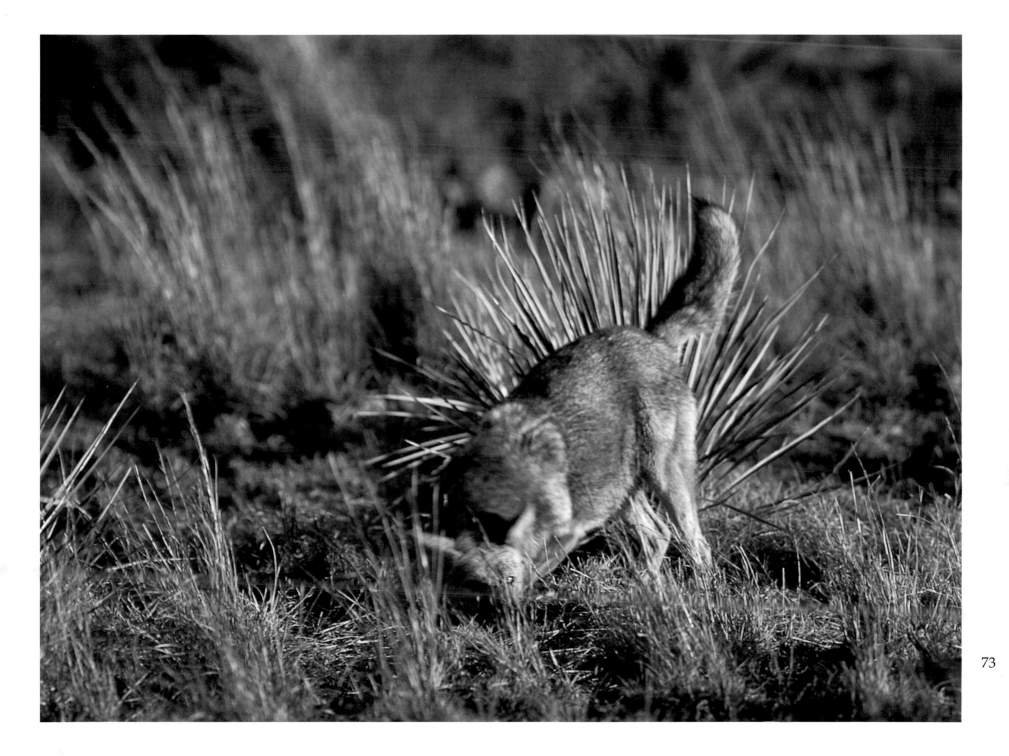

74

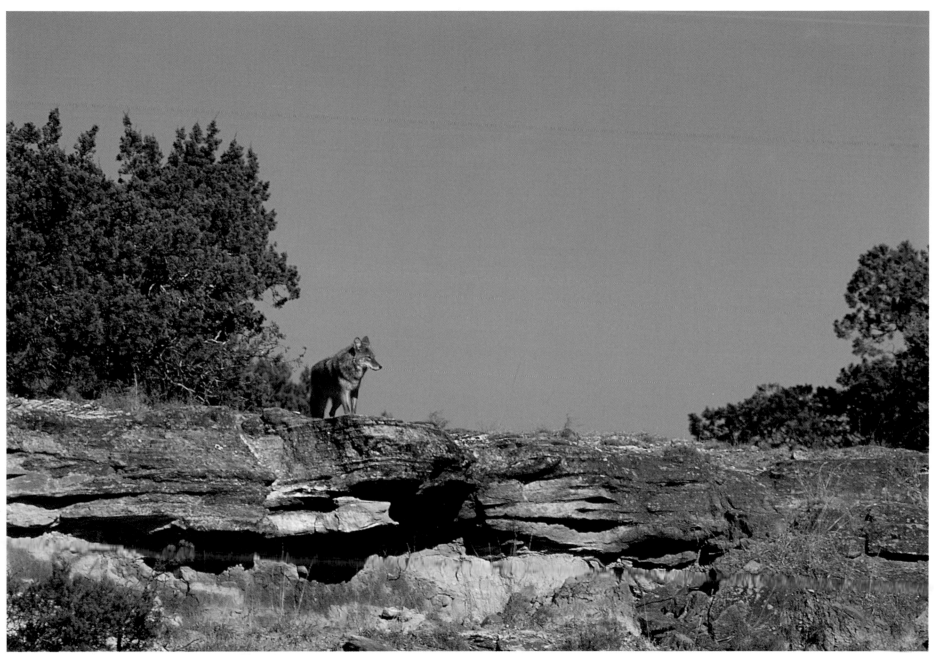

Coyotes often utilize rimrocks in their daily travels.

From July through September mesquite beans are a significant food source. Once accused of helping to spread the noxious mesquite, research has shown that the beans are rendered inviable after passing through the coyote's digestive system.

76

Prickly-pear fruit comprises a significant part of the diet in August and early September. Coyotes do not eat the pads.

Although quail and other birds such as prairie chickens or the hen-house chicken are readily eaten if available, they are not a primary food source. These quail appear at ease as they saunter by under the watchful eye of a coyote.

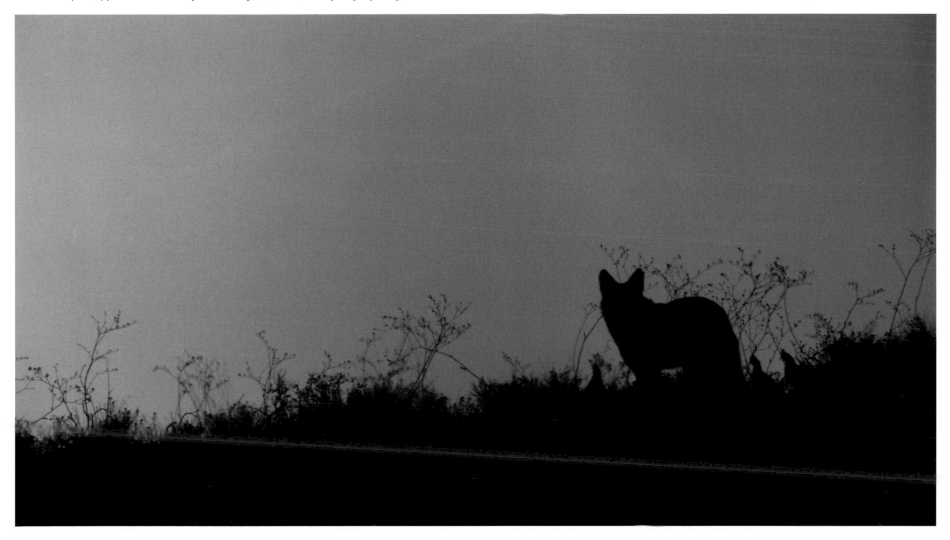

Hunting in the scrub mesquite of the Rolling Plains.

After feeding on a carcass, individuals often lie down near the food cache to rest and keep watch.

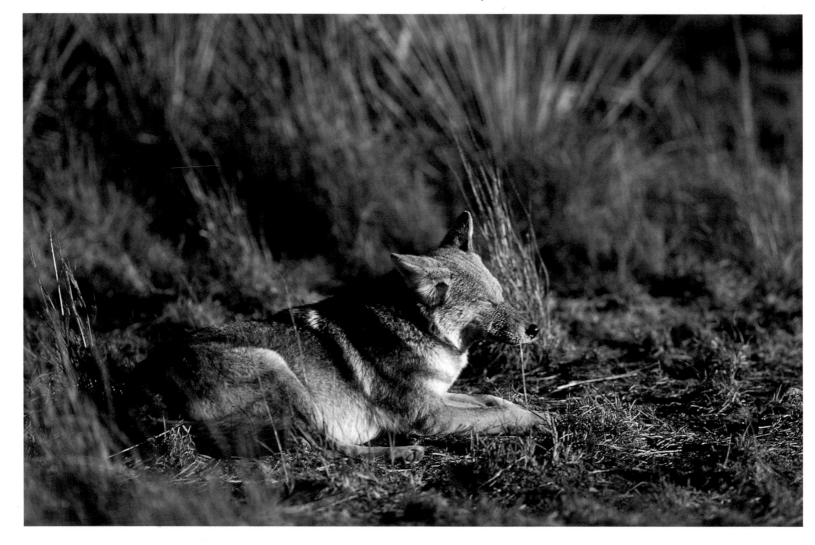

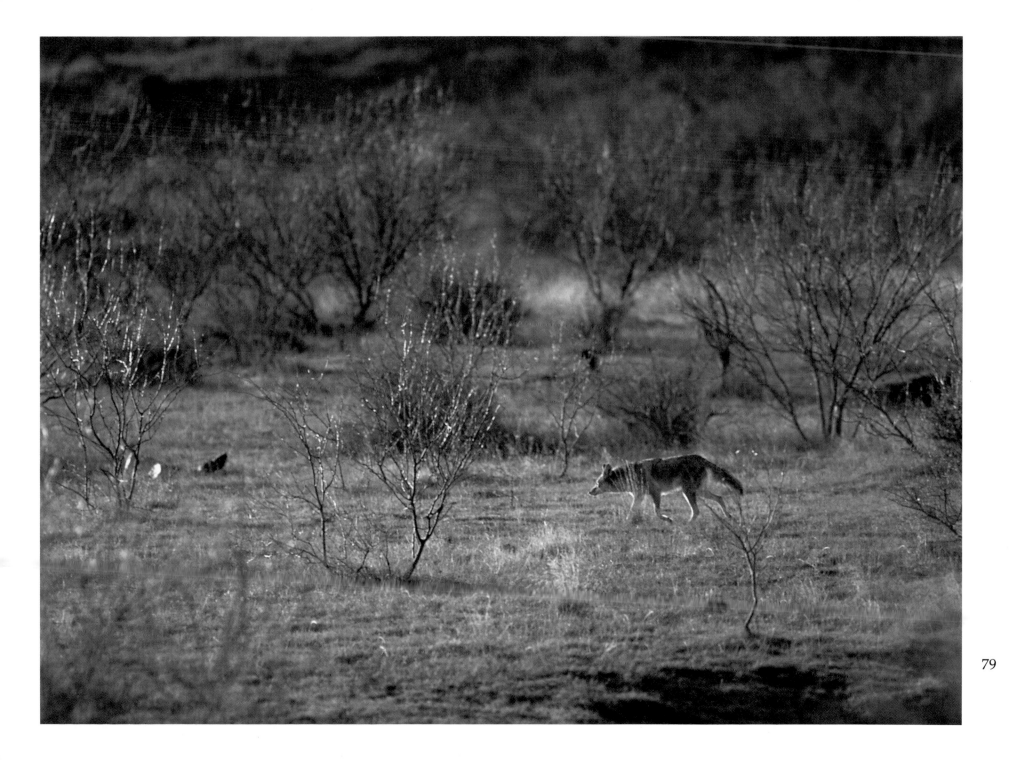

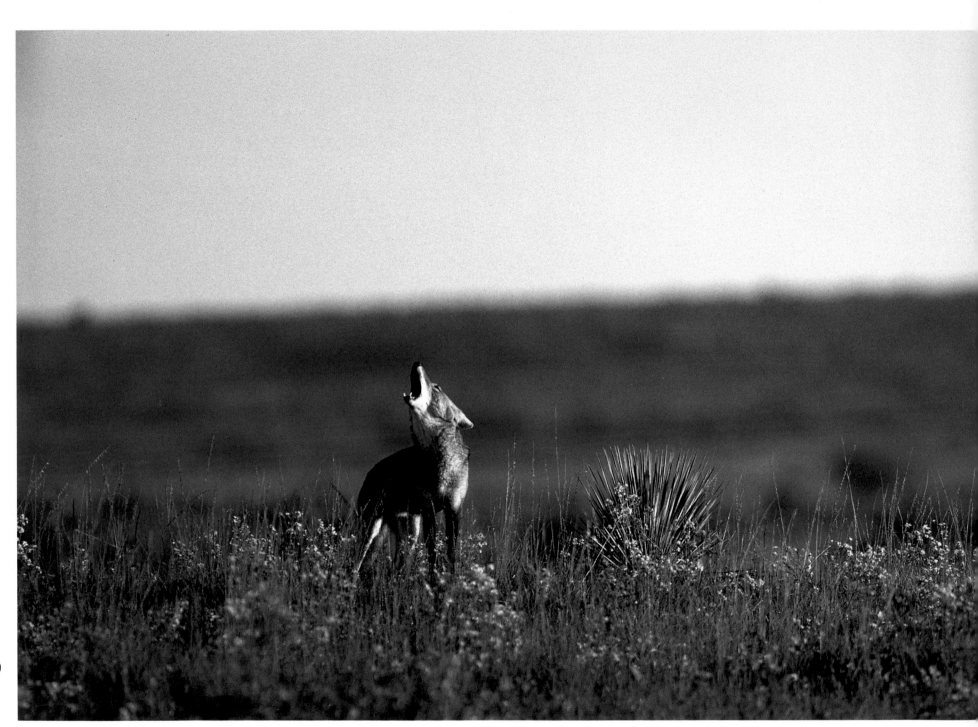

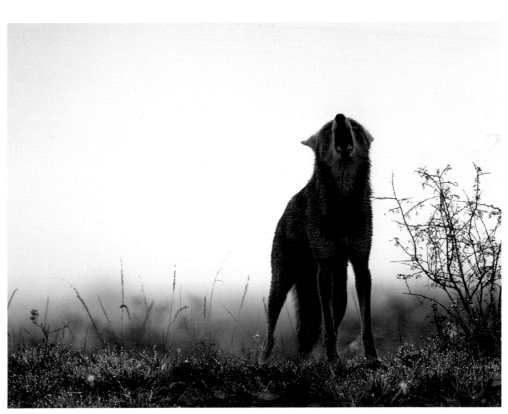

Contrary to the image of a lone animal howling beneath the moon, coyotes howl for several reasons—communication with others, as a warning, or even to signal a change in weather. A falling barometer can spark a bout of howling.

81

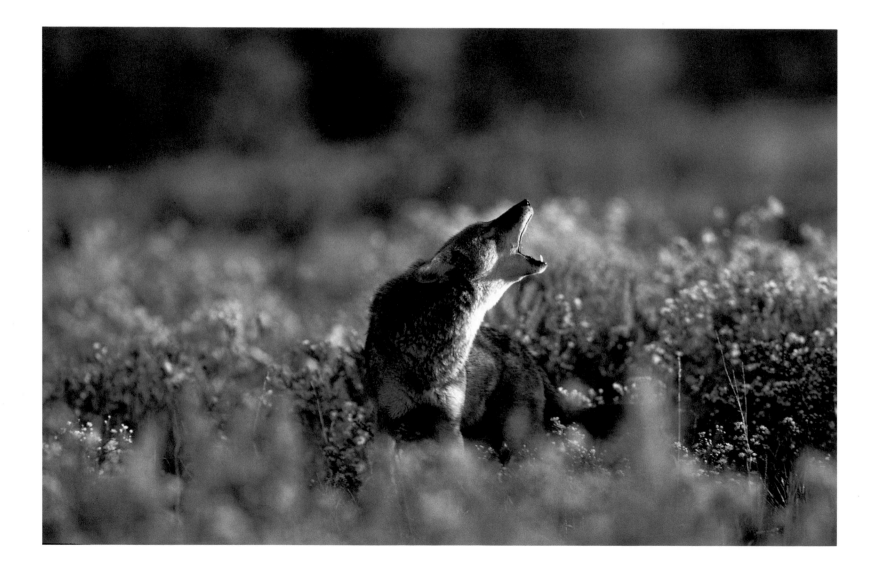

82

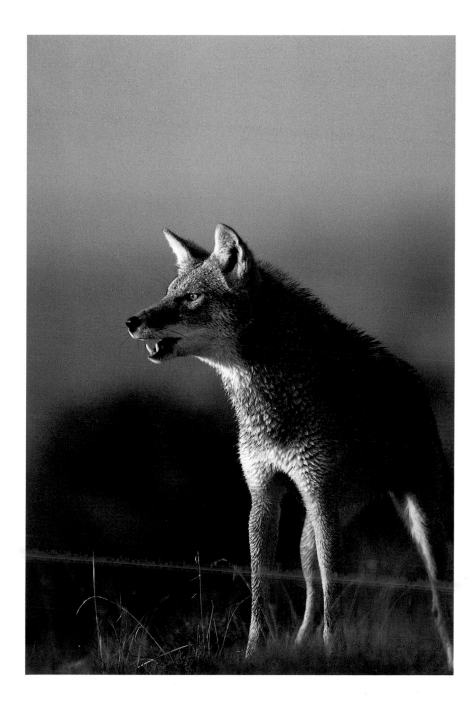

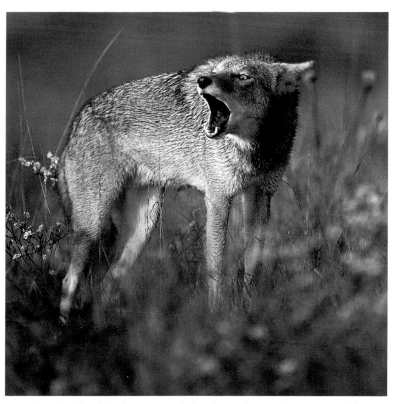

In springtime, howling (opposite and above) may have a physiological effect on breeding females. The population size is density dependent. A high incidence of howling may cause a reduction in litter size by possible fetus absorption.

A typical aggressive posture of a coyote (left). The tail is outstretched, and depending on the degree of aggression exhibited, the hackles rise first and then all the rest of the hair on its body.

83

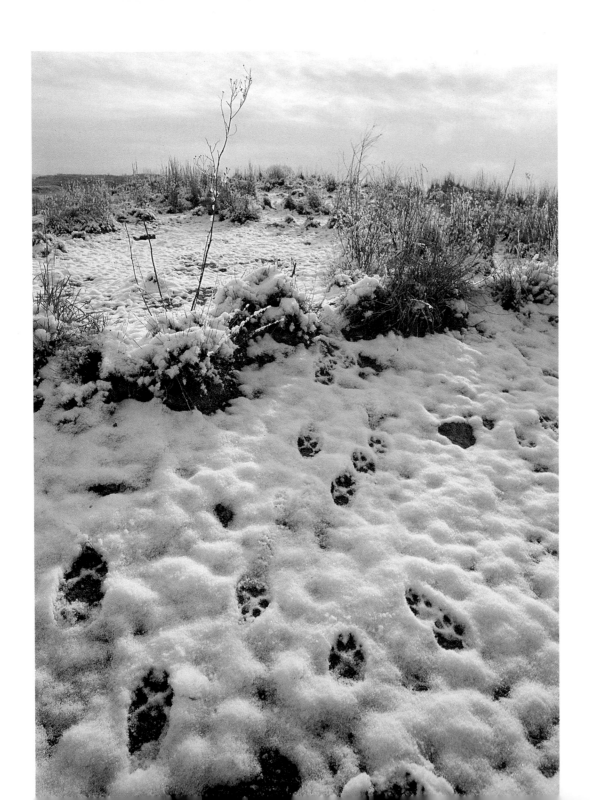

Coyote have five toes on their front feet (four that touch the ground plus a dewclaw) and four toes on their hind feet. The average walking stride is nine to twelve inches, depending on the size of the animal. At a run, the stride lengthens to three to four feet.

In the winter, the coyote is always on the move looking for food.

84

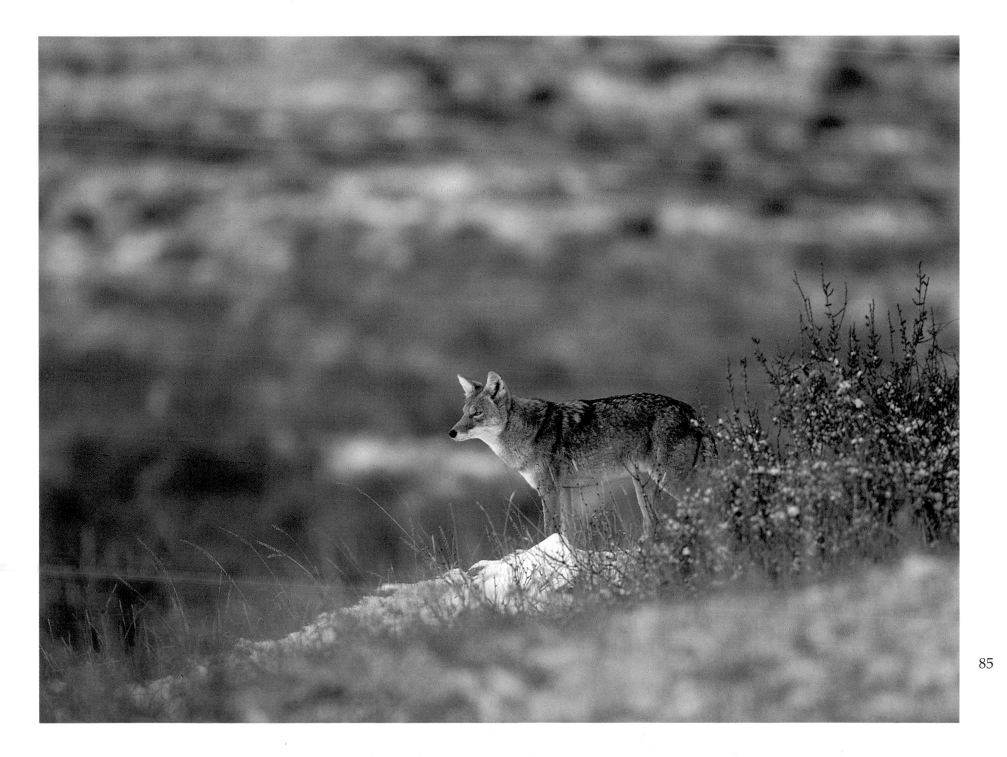

Dens are typically located in
sandy banks or under rock
outcroppings. The sites are
newly excavated by the parents
or when available they will
enlargen a badger hole.

Pups are blind for the first ten
days after birth and emerge from
den within two to three weeks.

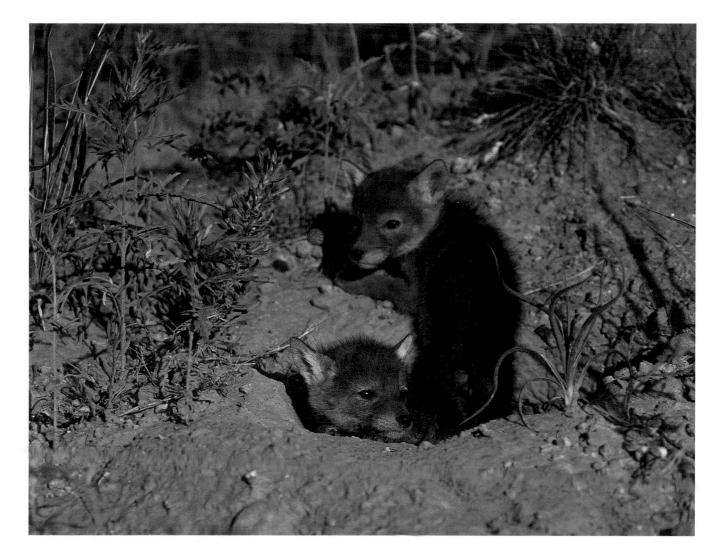

The average den is nine feet long and thirty-six inches below ground surface. Most dens have an enlarged nursing area; some have separate nursing quarters with side chambers for the pups.

An eight-week-old pup peers from the den for possible danger. Pups are susceptible to predation from bobcats, badgers, owls, and large hawks. They are alone for long periods while the adults are hunting. When adults are not hunting, they usually find an elevated location about ten to twelve yards from den to rest and keep watch.

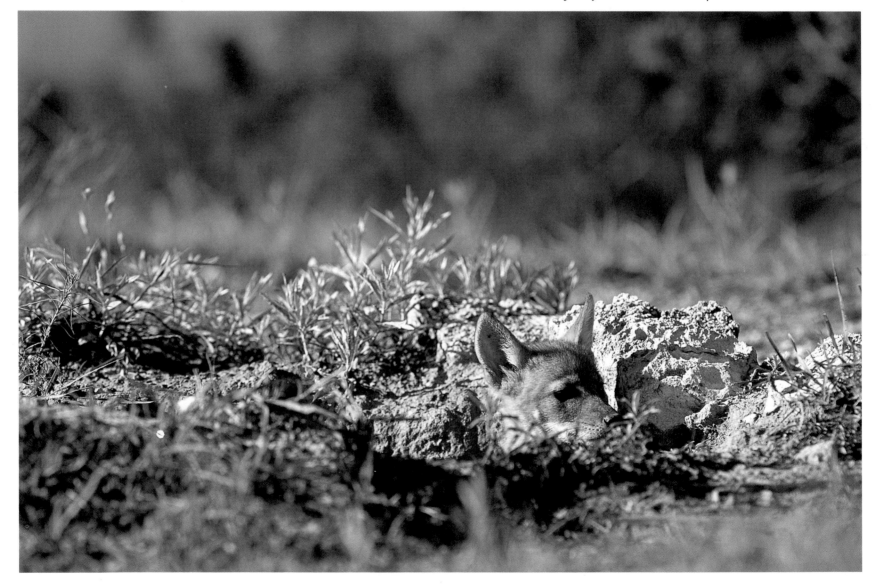

Tracks of a naturally deformed coyote with three toes on both front and back feet.

Two adults on an early winter morning.

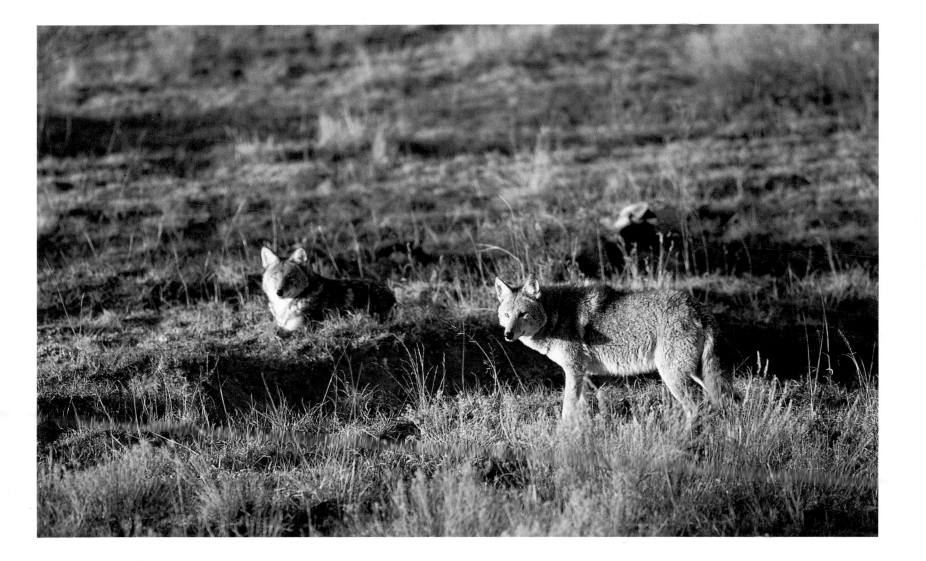

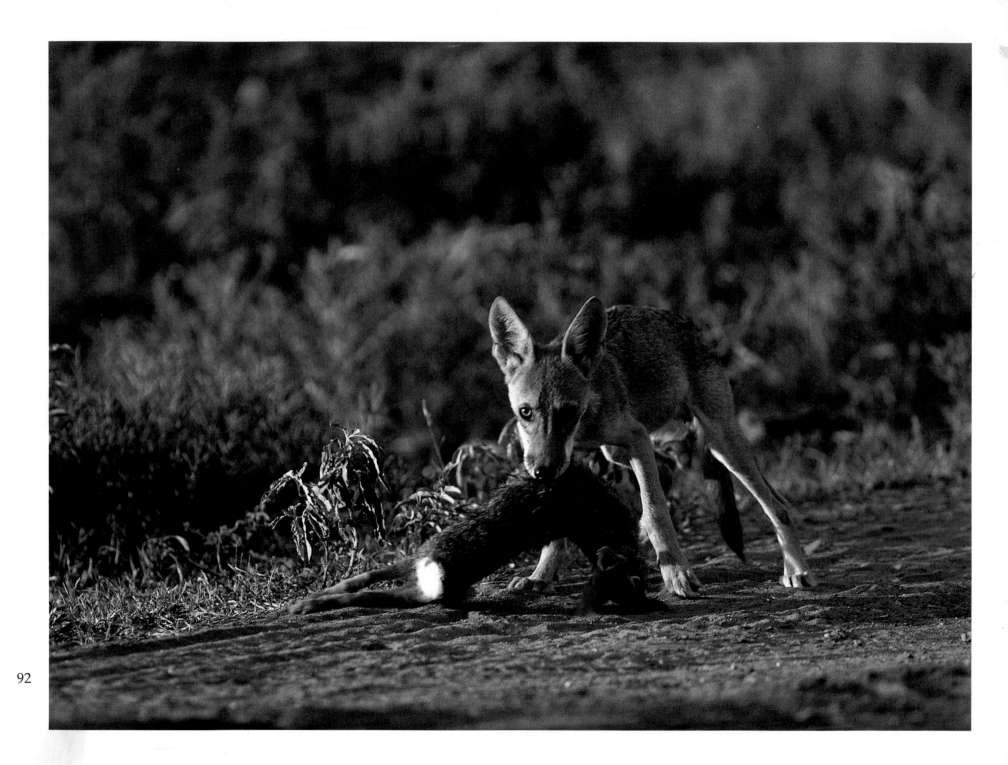

92

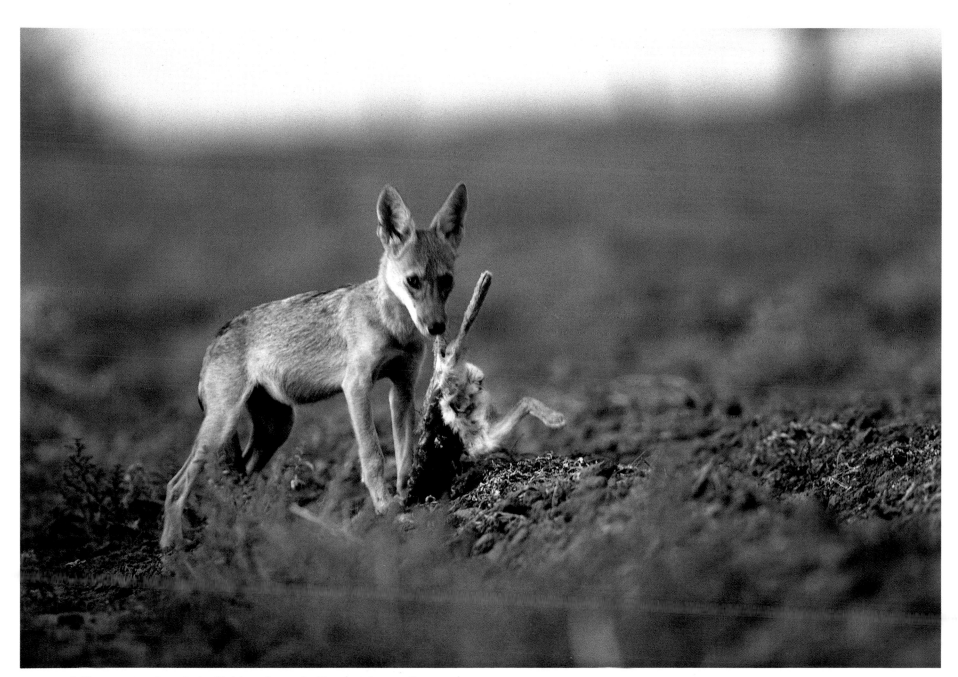

Still too young to hunt for itself, this twelve-week-old pup receives small prey items such as rabbits, rats, and mice from either adult. Pups are weaned at six to eight weeks and by six months are on their own.

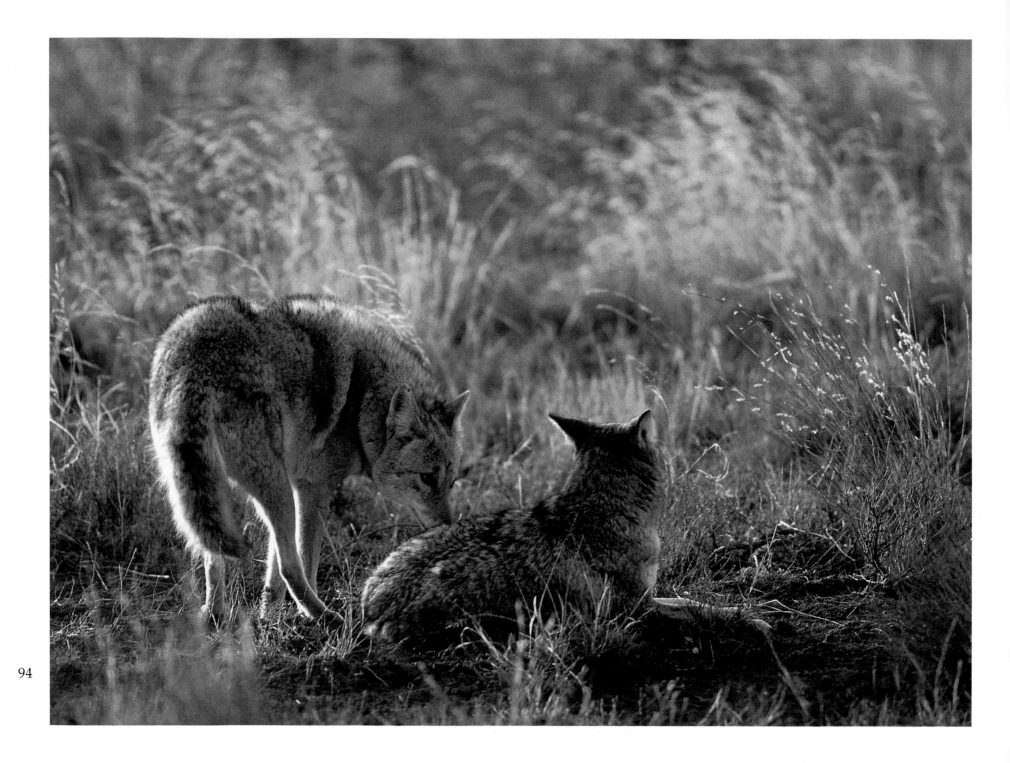

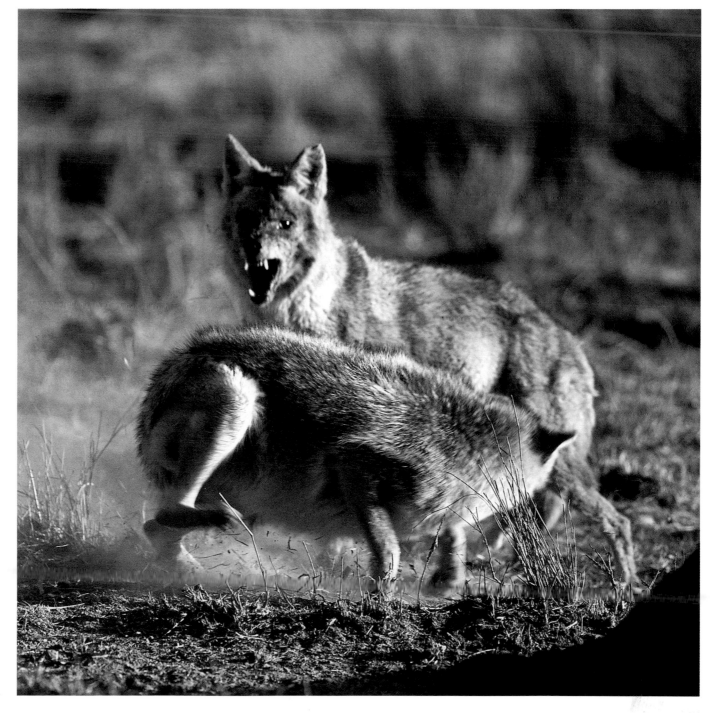

When approached by a dominant male, a subordinate animal assumes a submissive posture and does not make eye contact.

Disputes about rank within the dominance hierarchy are settled quickly. The subordinate animal has its tail tucked under its belly.

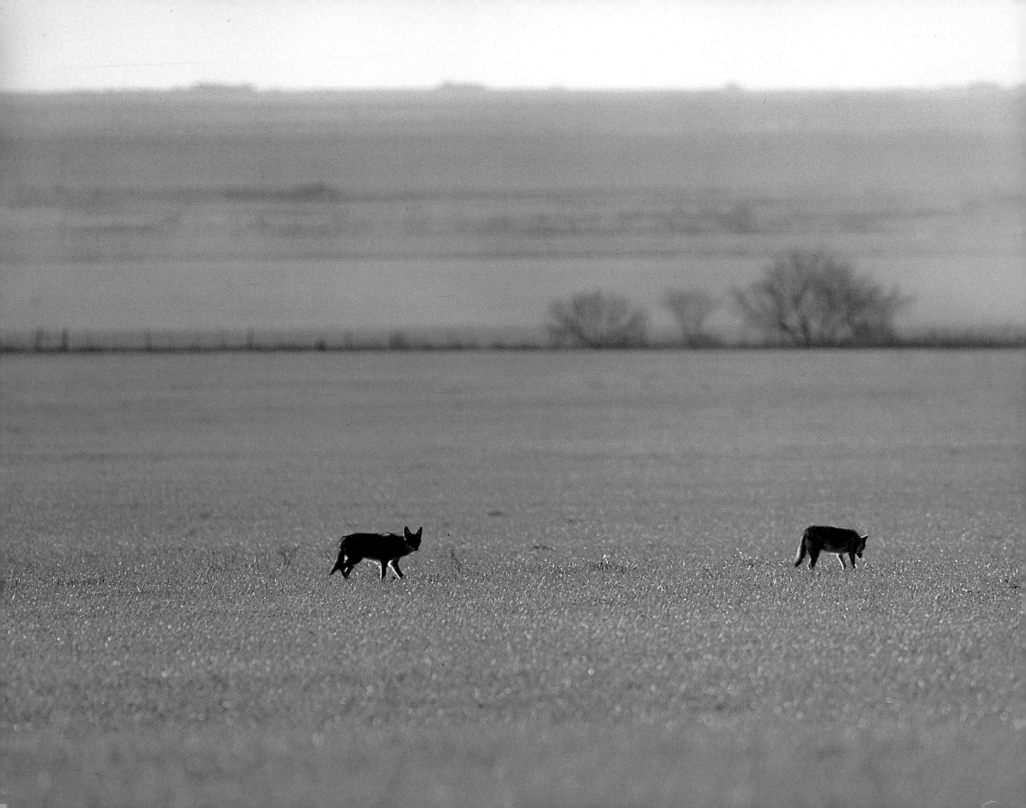

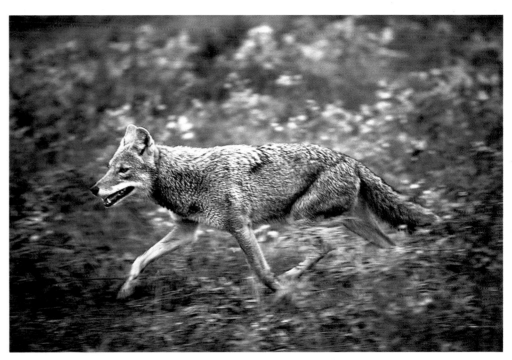

A tireless traveler, a coyote can maintain a fast trot for hours on end if necessary.

Two coyotes hunt an open wheat field on the Rolling Plains.

97

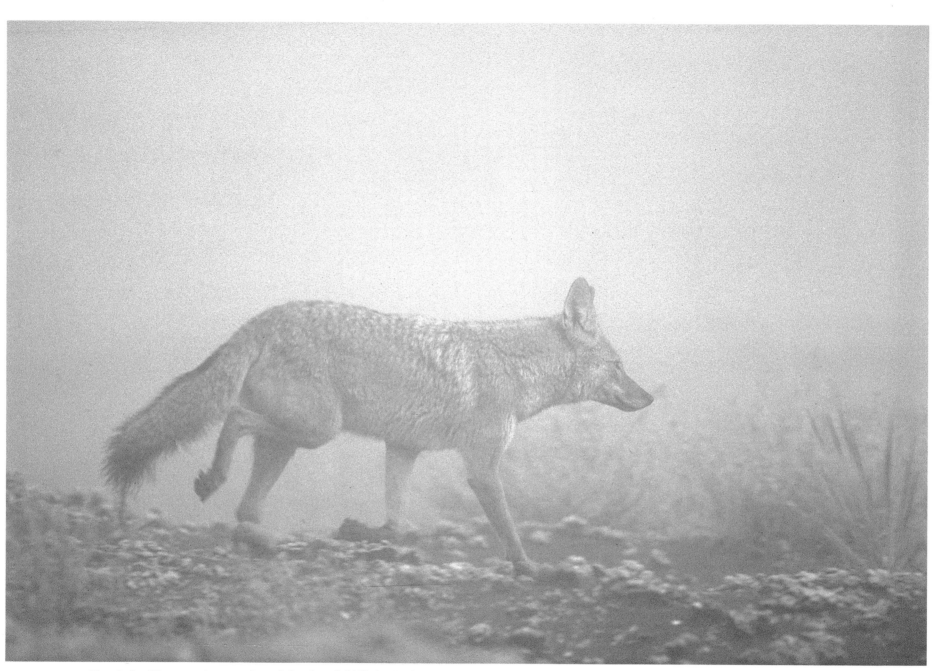

Almost ghostlike, a coyote moves through fog-shrouded hills in North Texas.

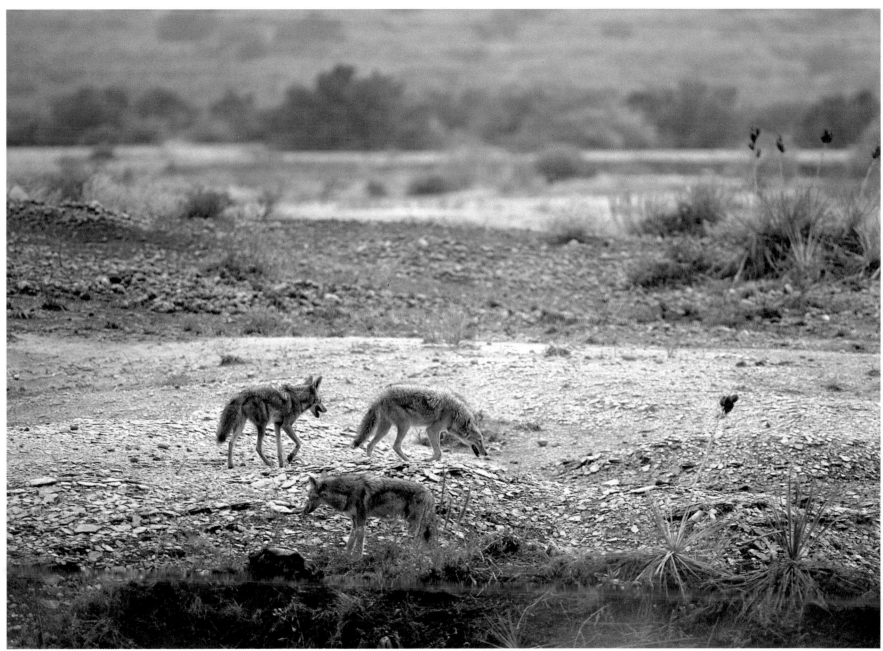

These siblings are five months old and are still in their family unit. By about six months of age the families disperse.

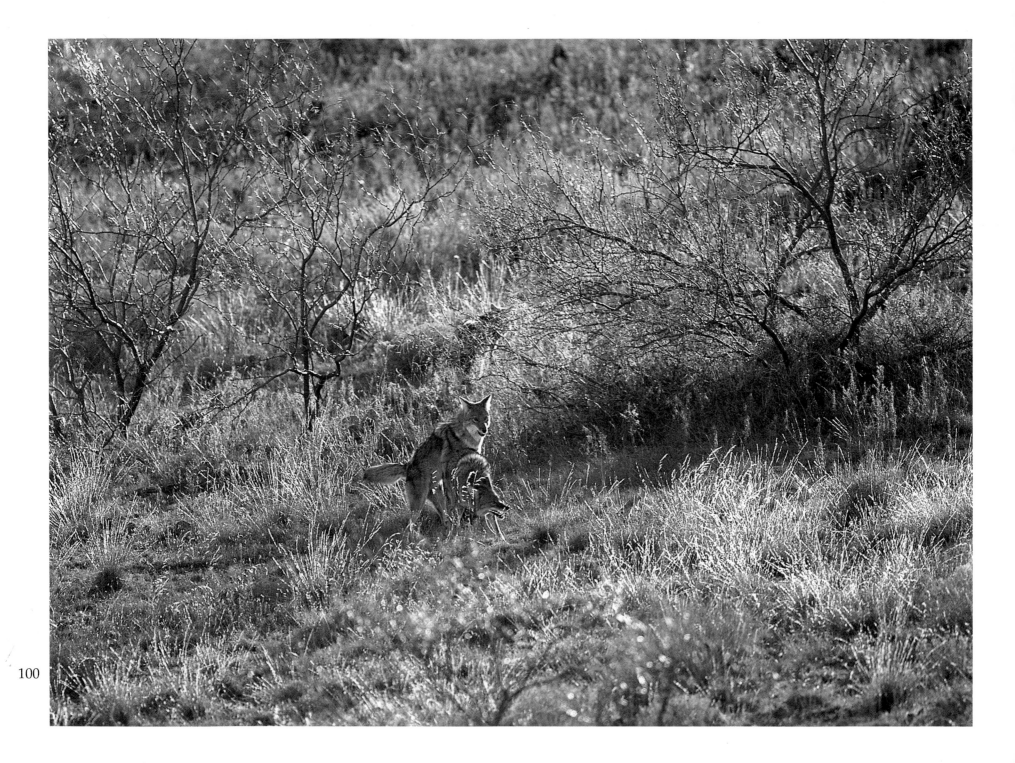

Mating occurs in February on the Rolling Plains, and pups are born in early May. In this region, a female produces a litter of four to seven pups. The number of pups produced is density dependent; in areas where the coyote population is high or food supply is low, females produce fewer pups.

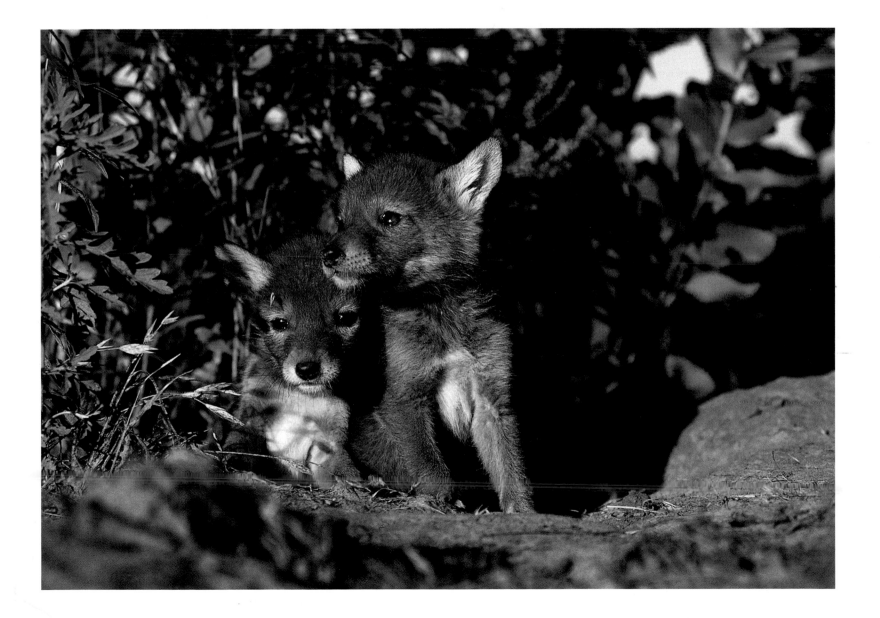

Sometimes individuals will hunt in pairs. Even when watching for prey species they are also vigilant for danger.

This coyote saw me lying in the grass waiting to photograph him. Uncertain of the danger I presented, he cautiously moved downwind to pick up my scent.

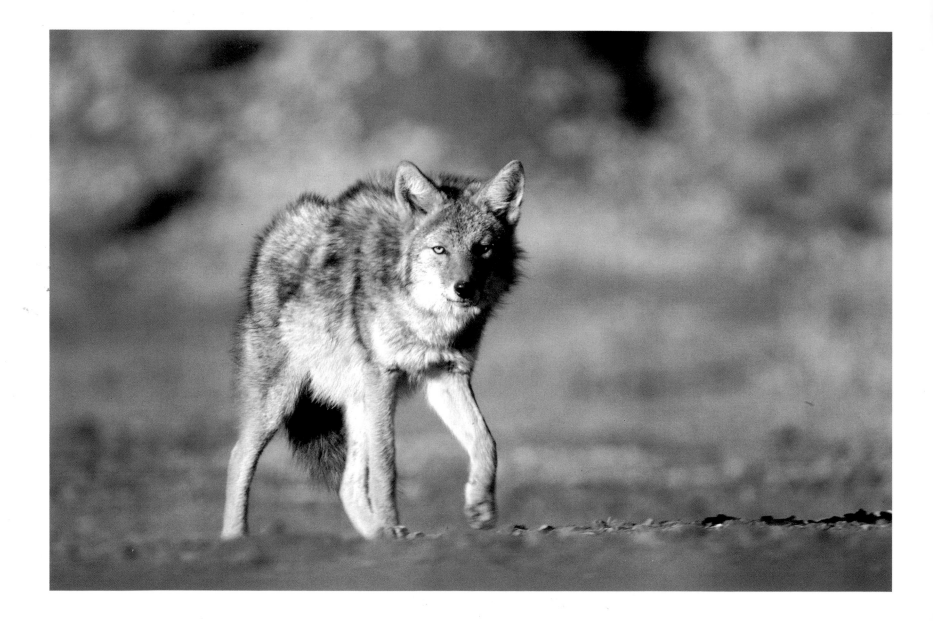

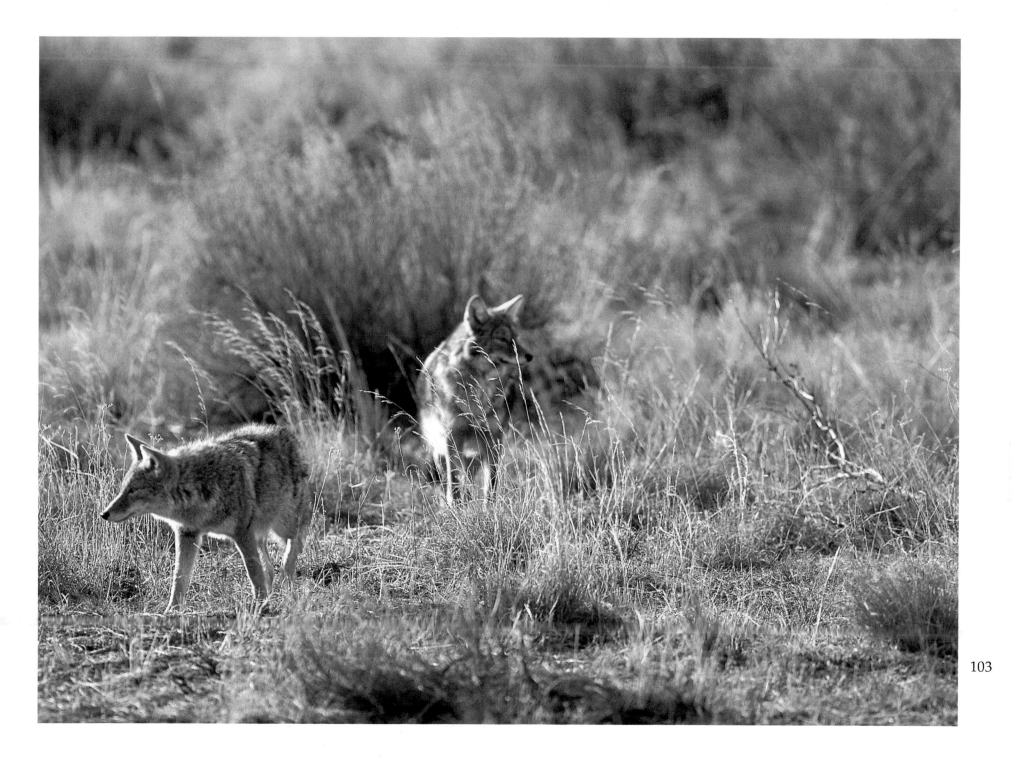

103

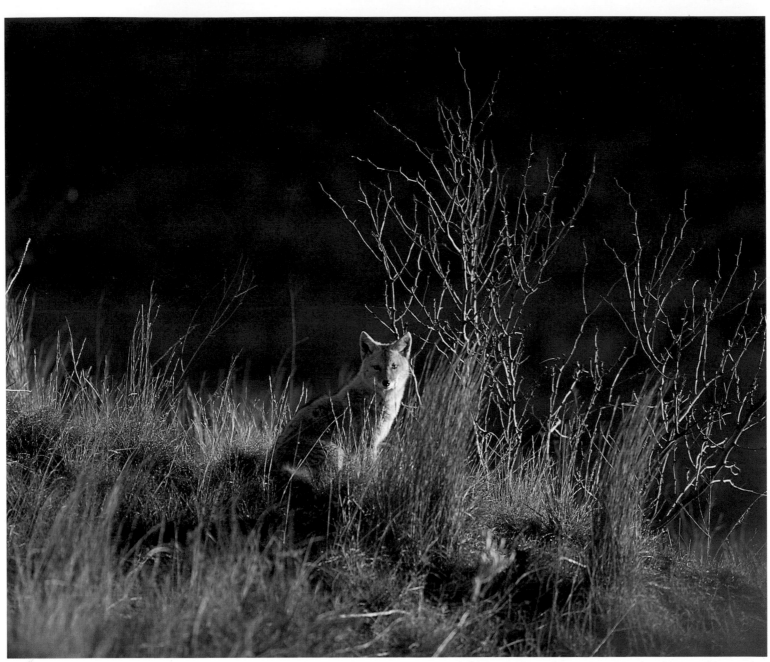

A juvenile warms in the early morning rays of a cold December morning.

Coyotes pair for several seasons, if not for life. Pairs (male, right; female, left) remain together as long as the den is active. Occasionally pairs will remain together after the pups disperse.

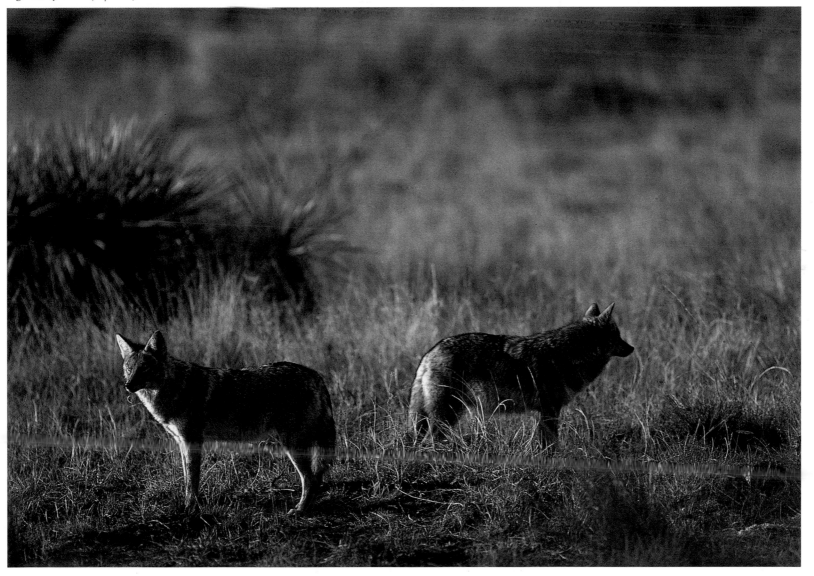

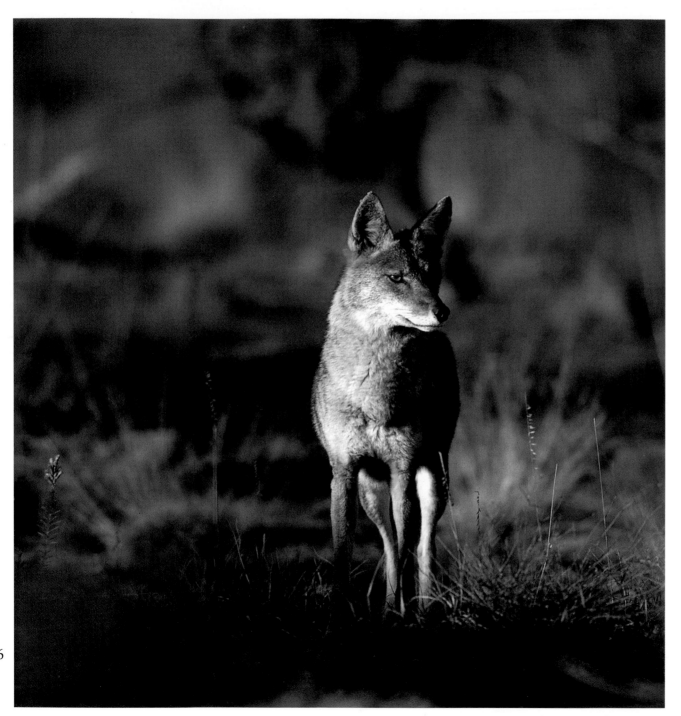

The ever vigilant coyote uses its eyes, nose, and ears to locate food or warn of danger.

This animal has been ear-tagged by a researcher. Studies on the Rolling Plains indicate that animals have a home range of about nine square miles.

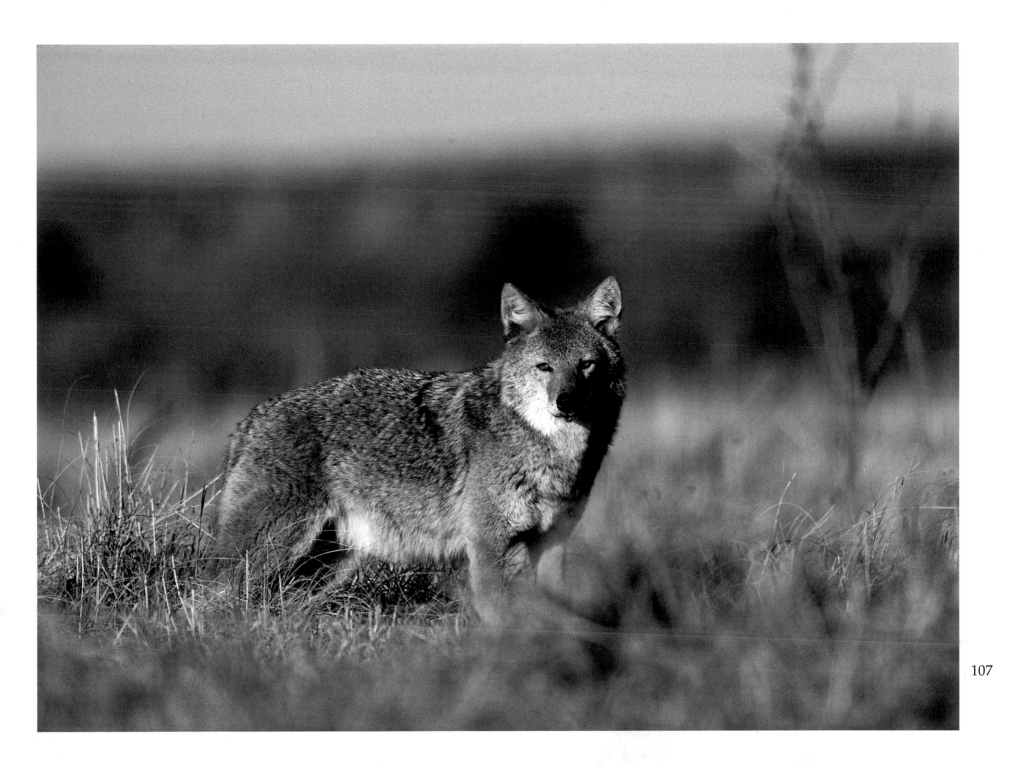

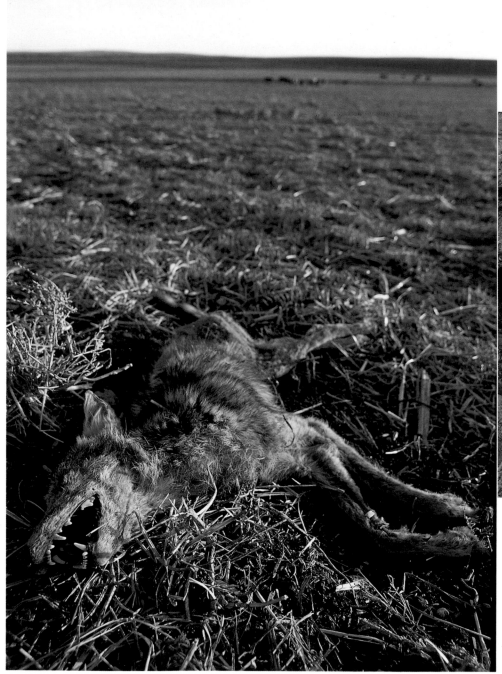

Sarcoptic mange is a major health problem for coyotes across Texas. The condition is caused by a mite that burrows under the skin causing severe itching. The animal spends most of its time biting, scratching, and rubbing the infected area. Gradually its fur is lost and what little remains has lost most of its insulative ability. The coyote becomes weaker and must seek shelter such as this cave. Death is lingering and almost one hundred percent certain from secondary infection.

Despite extensive eradication attempts in the twentieth century, the coyote population is expanding. Their range now extends from New England to California, Alaska to Guatemala.

109

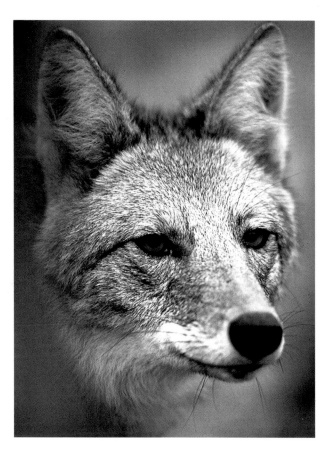

When readily available water cannot be found, coyotes excavate holes in stream beds. These temporary watering holes are used by many other creatures seeking water during the dry season.

110

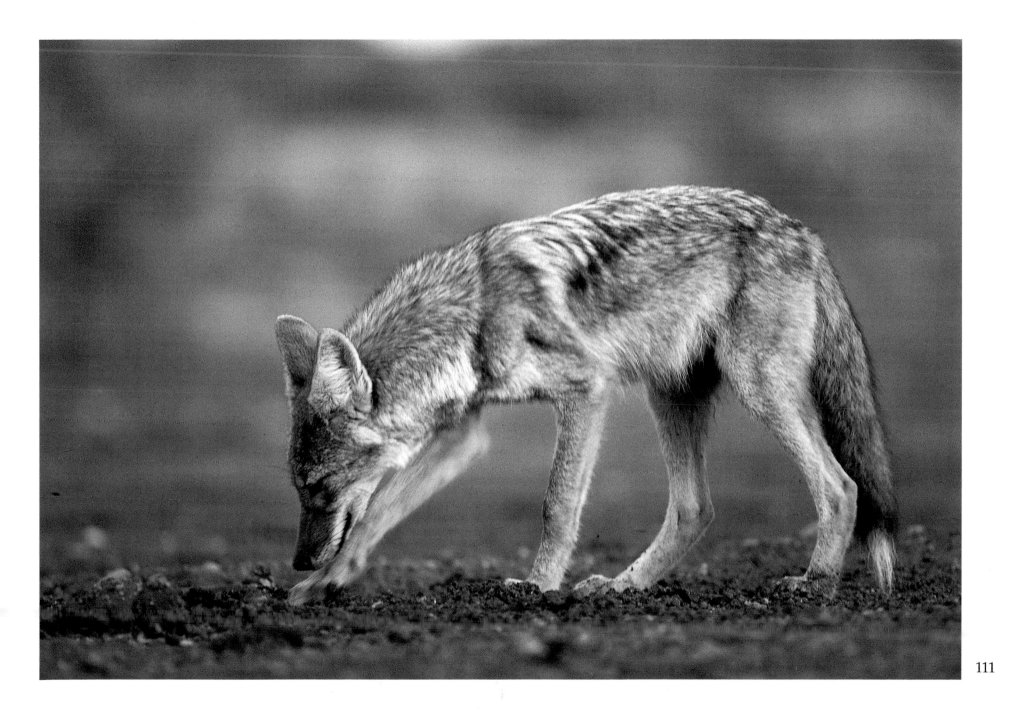

When stalking prey, individuals will use natural obstacles to hide their approach.

Bodily injury often occurs from fighting or accidents. This coyote probably lost his eye by an encounter with a mesquite thorn or in a fight.

112

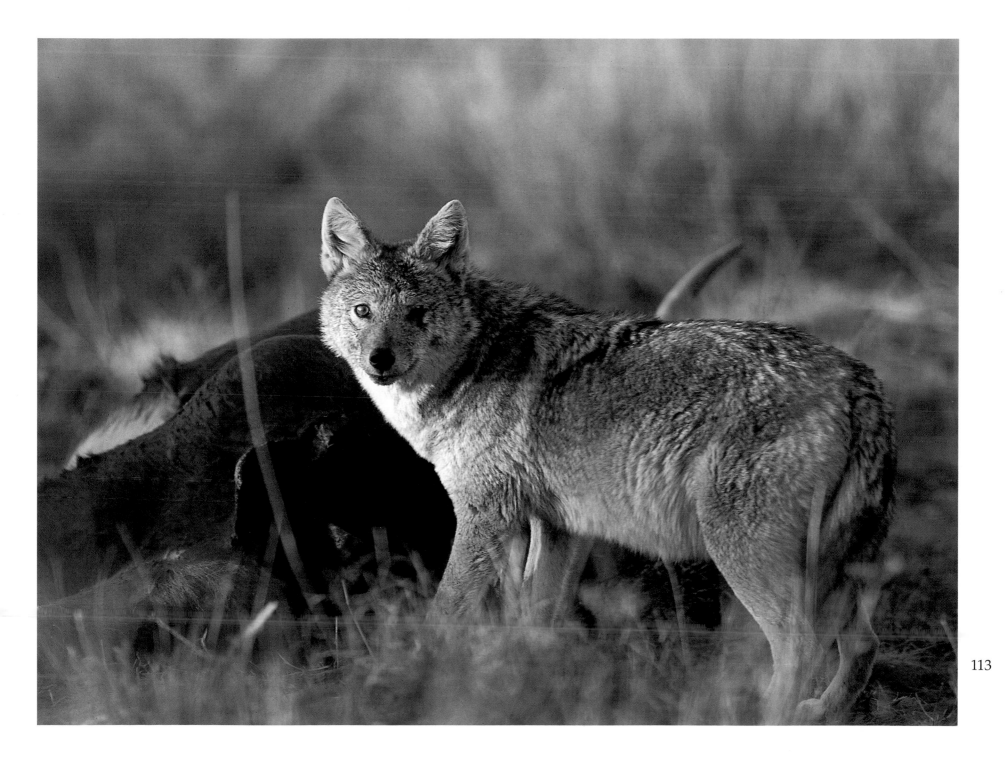

Fights between dominant and subordinate animals are usually quick and decisive. The dominate animal chases the loser a short distance before returning to the food cache.

Often an animal at a food cache will turn, gallop to challenge any approaching animals, and exhibit aggressive posture, perhaps adhering to the adage that a good offense is the best defense.

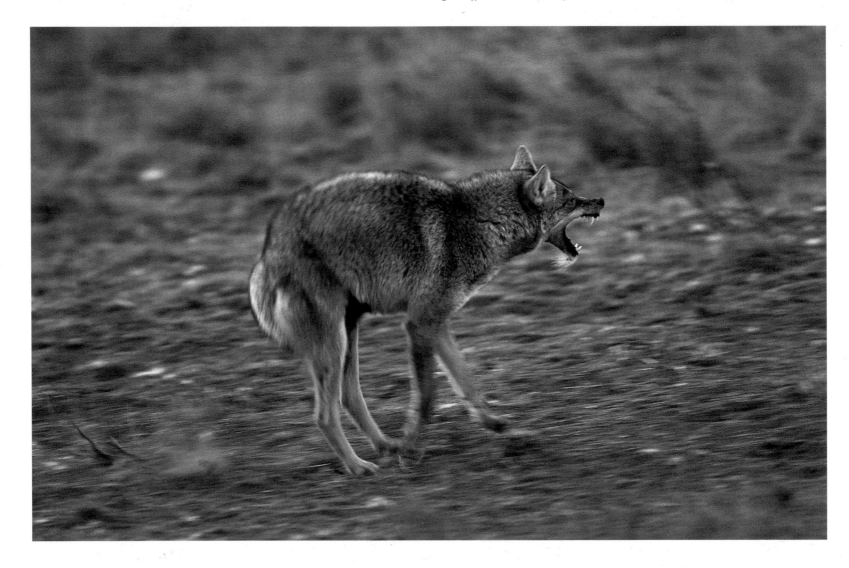

115

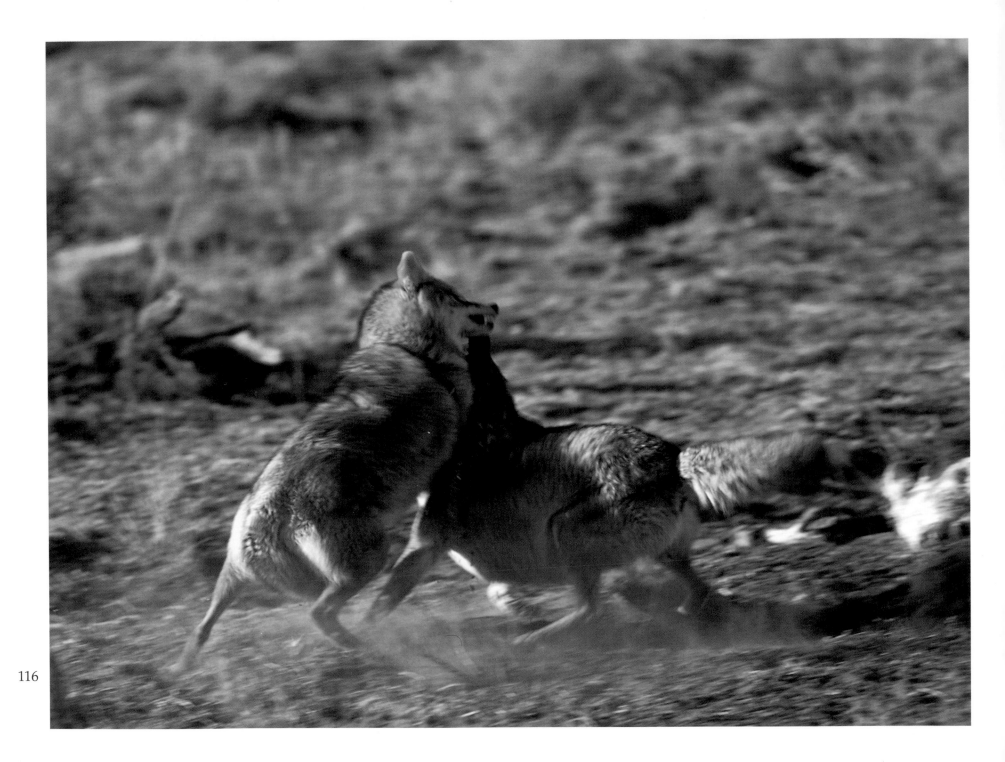

116

A fight between two dominant males. Fights between dominant individuals last longer and occur several times before one is driven from the food source.

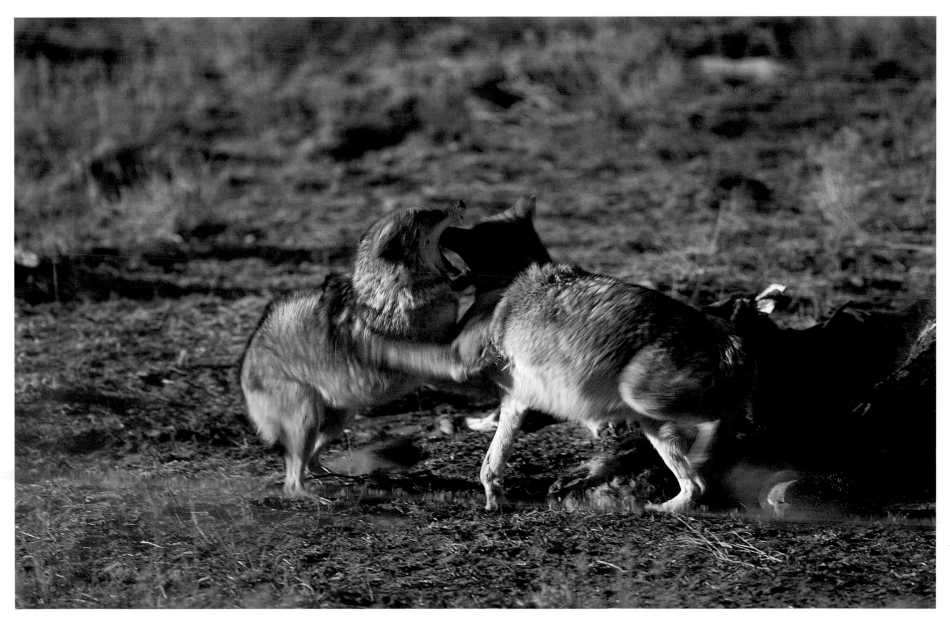

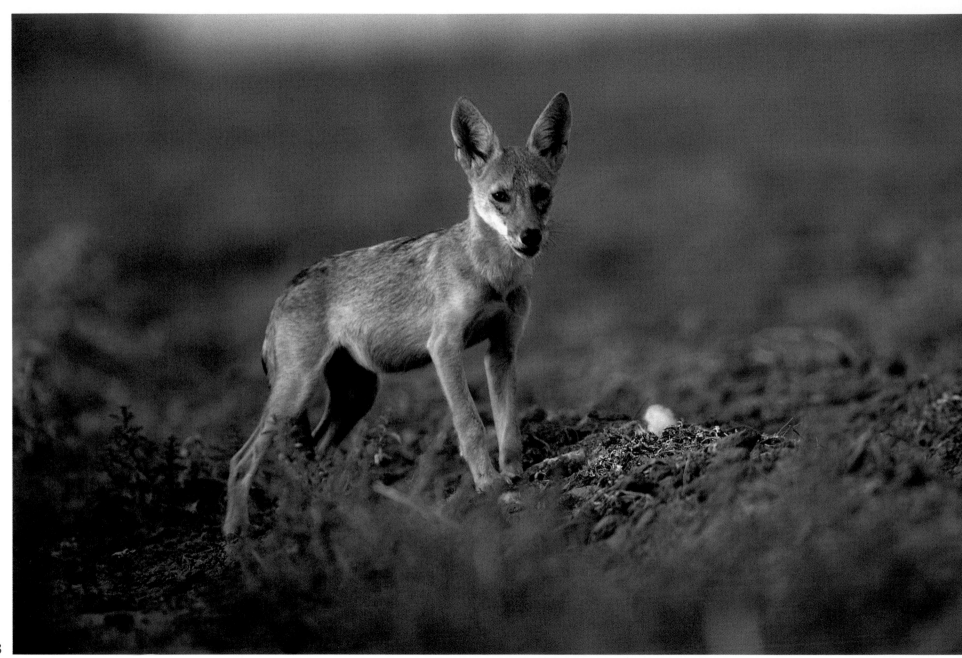

Note the long legs, overly large ears, and large eyes of this twelve-week-old pup.

Pups will often leave the den to find a shady shelter from the hot July sun.

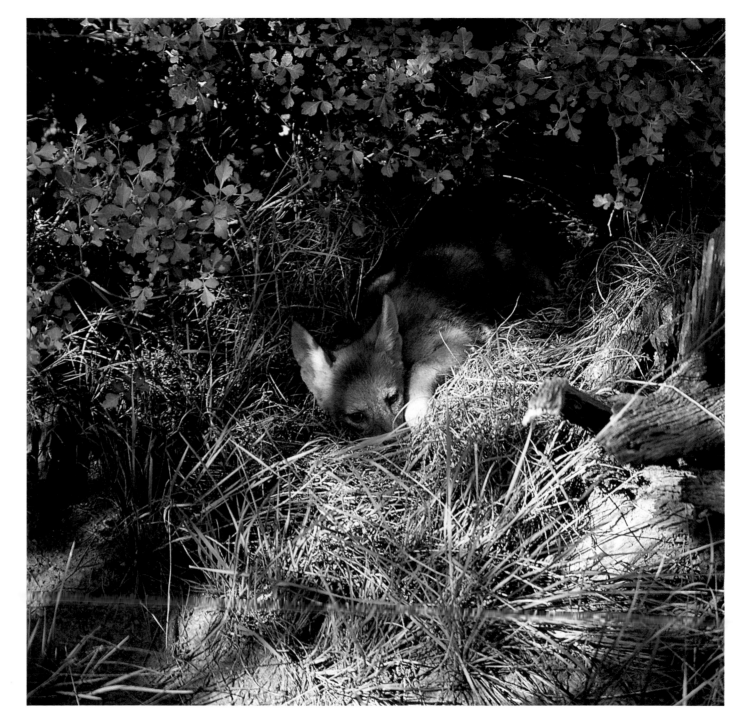

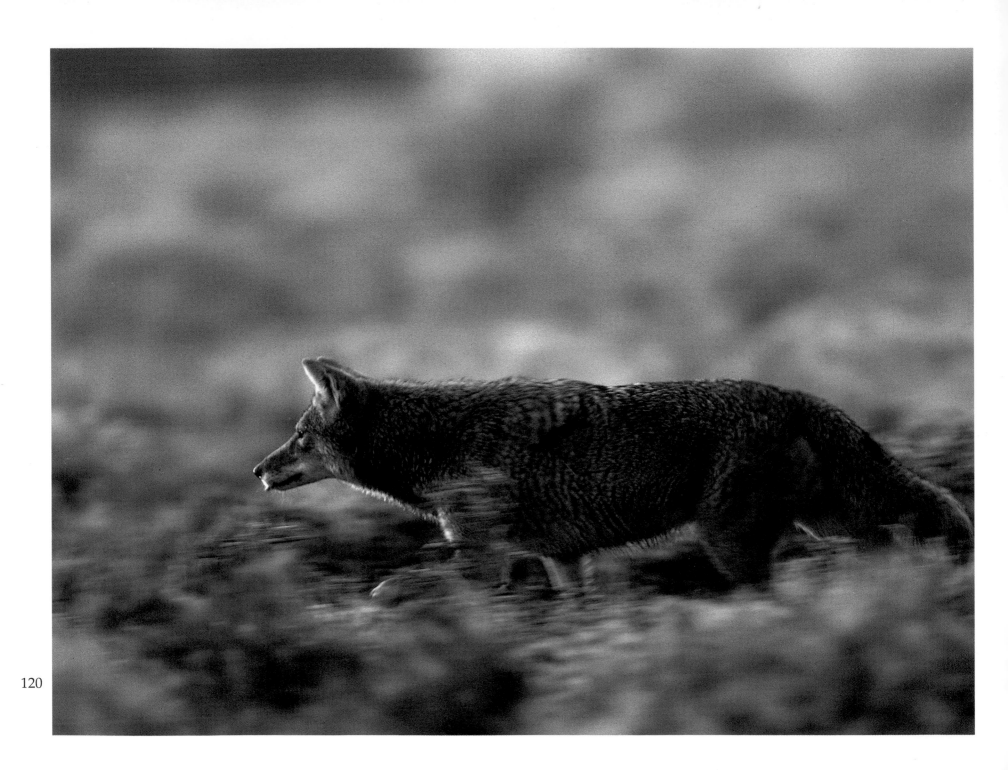

After pinpointing its intended its prey, the coyote moves in swiftly to make its kill.

Full from a heavy feeding, this individual ambles off a short distance to rest.

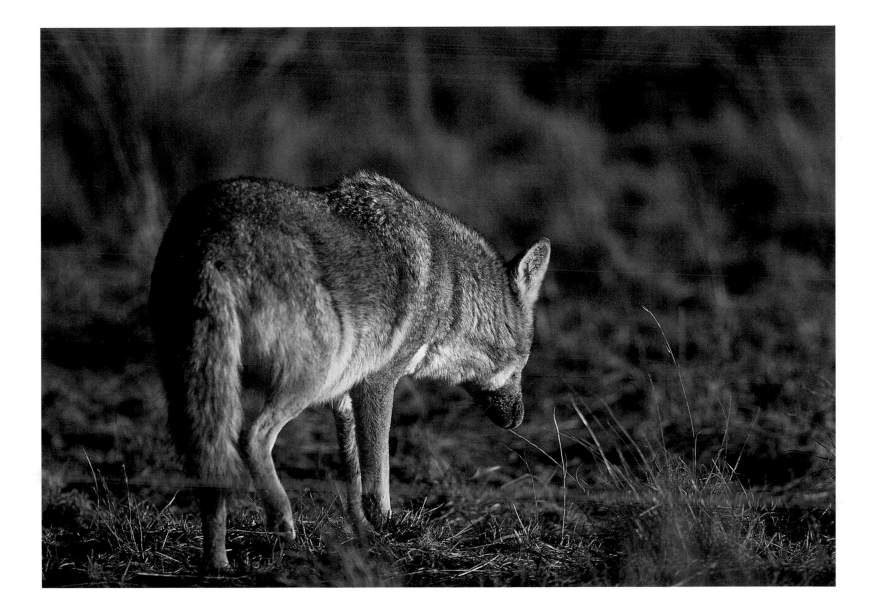

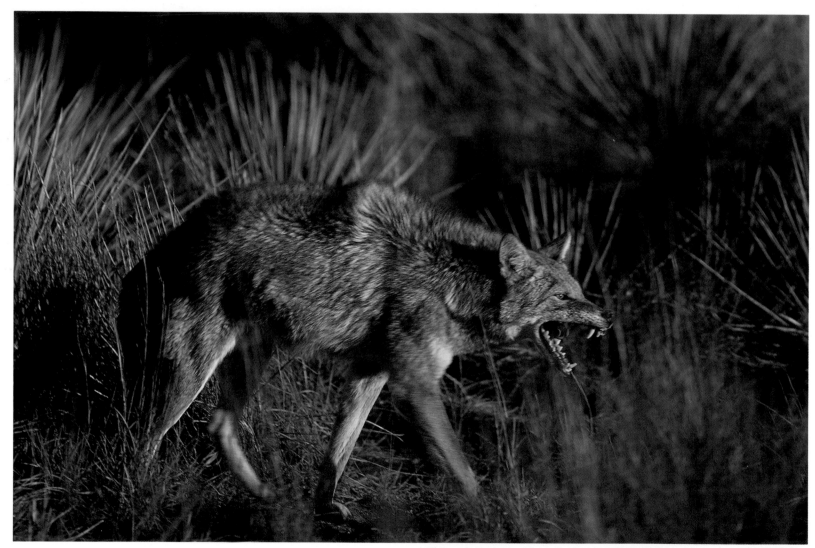

122

This male is approaching a food cache inhabited by another coyote. Uncertain of his status with those present he assumes an aggressive posture—head lowered, teeth bared, hackles raised, and his tail is low, but not tucked under his belly.

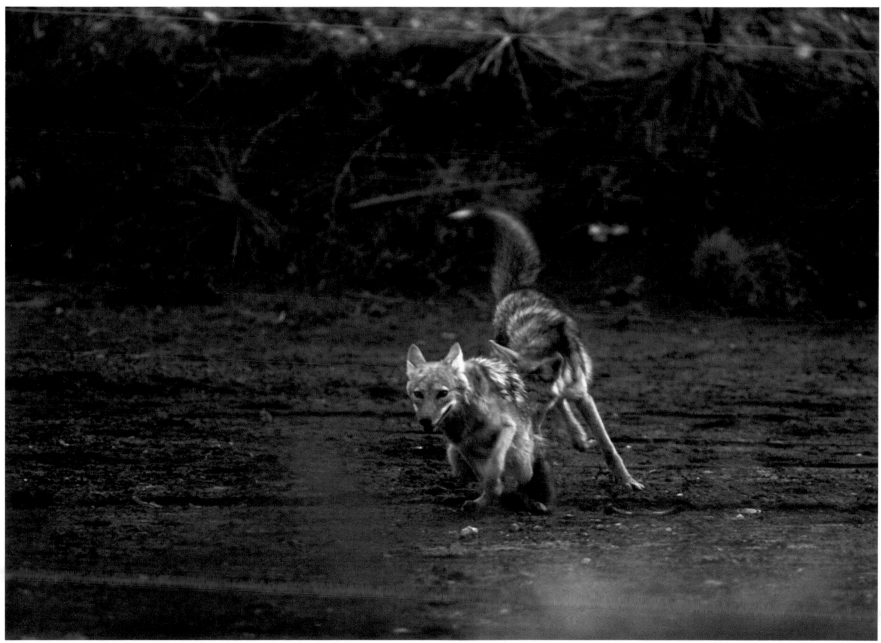

These five-month-old sibling pups are establishing their pecking order at a food cache.

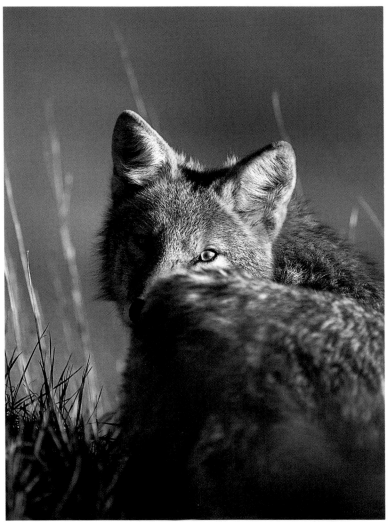

Forced at a distance from a food source by a dominant animal, subordinate animals wait for a chance to grab a bite to eat, as well as remaining alert for an attack by a dominant male.

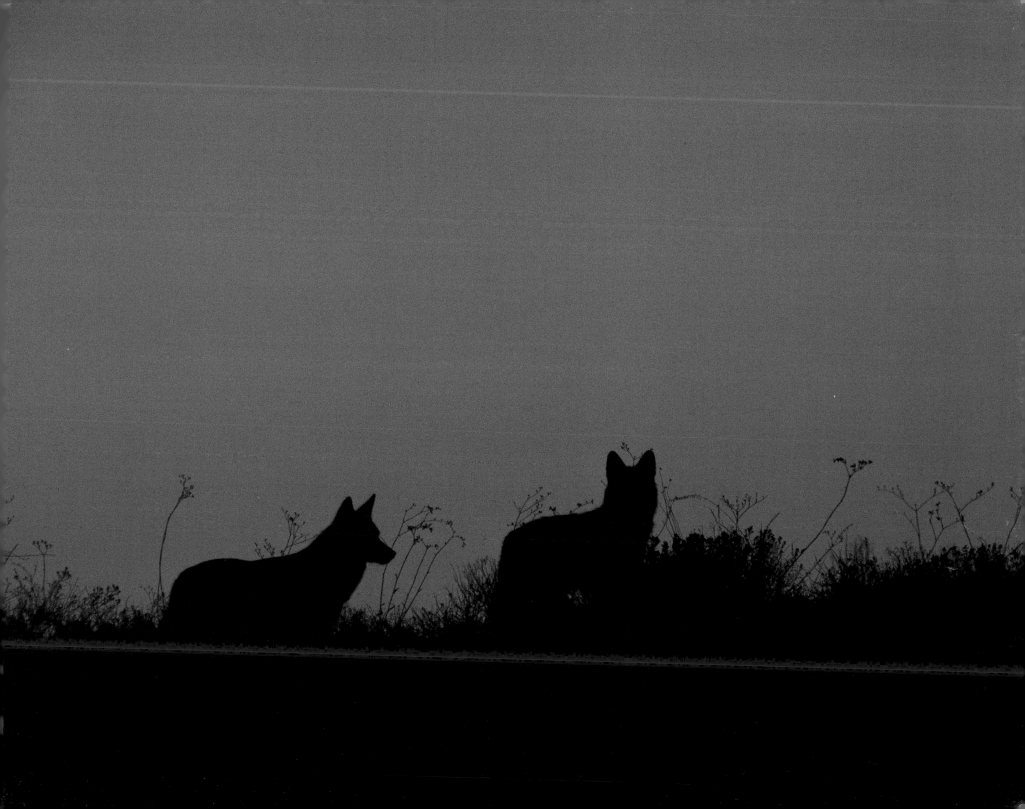

BIBLIOGRAPHY

Aoki, Harvo, and Deword E. Walker Jr. *Nez Perce Oral Narratives.* Berkeley: University of California Press, 1989.

Bekoff, Marc. Canis latrans. *Mammalian Species,* No. 79 (1977).

Bekoff, Marc, ed. *Coyote: Biology, Behavior and Management.* New York: Academic Press, 1978.

Bright, William. *A Coyote Reader.* Berkeley: University of California Press, 1989.

Dobie, J. Frank, Mody C. Boatright, and Harry H. Ransom. *Coyote Wisdom.* Austin: Texas Folk-Lore Society, 1938.

Guthrey, Fred S., and Wyman Meinzer, Jr. "Age Distributions and Weights of Coyotes in Northwestern Texas." *Southwest Naturalist* 25 (1980): 275-278.

Harrison, Daniel J., Joyce A. Harrison and M. O' Donohue. "Predispensal Movements of Coyote Pups in Maine." *Journal of Mammalogy* 72, No. 4 (1991): 756-763.

Levine, Sigmund A. *Wonders of the Coyotes.* New York: Dodd, Mead, and Company, 1984.

Leydet, Francois. *The Coyote: Defiant Song Dog of the West.* San Francisco: Chronicle Books, 1977.

Luckert, Karl W. *Coyote Way.* Tucson: University of Arizona Press, 1979.

Malotki, Erkehart, and Michael Lometoway. *Hopi Coyote Tales.* Lincoln and London: University of Nebraska Press, 1984.

Meinzer, Wyman P., Darrel N. Ueckert, and Jerron T. Flinders. 1975. "Foodniche of Coyotes in the Rolling Plains of Texas." *Journal of Range Management* 28, No. 1 (January 1975): 22-27.

Minta, Steven C., Kathryn A. Minta, and Dale F. Lott. "Hunting Associations Between Badgers *(Taxidea taxus)* and Coyotes *(Canis latrans)*." *Journal of Mammalogy* 73, No. 4 (November 1992): 814-820.

Newcomb, Franc Johnson. *Navaho Folk Tales.* Santa Fe: Museum of Navaho Ceremonial Art. 1993.

Paquet, Paul C. "Scent-Marking Behavior of Sympatric Wolves *(Canis lupus)* and Coyotes *(Canis latrans)* in Riding Mount National Park." *Canadian Journal of Zoology* 69, No. 7 (July 1991): 1721-1727.

Pence, Danny B., and Lamar A. Windberg. "Impact of a Sarcoptic Mange Epizootic on a Coyote Population."

The Journal of Wildlife Management (in press): 1994.

Pence, Danny B., and Wyman P. Meinzer. "Blindness in a Coyote from the Rolling Plains of Texas." *Journal of Wildlife Diseases* 13 (April 1977): 155-159.

Pence, Danny B., Lamar A. Windberb, Barbara C. Pence, and Robert Sprowls. "The Epizootology and Pathology of Sarcoptic Mange in Coyotes, *Canis latrans*, from South Texas." *The Journal of Parasitology* 69, No. 6 (December 1983): 1100-1115.

Pringle, Lawrence. *The Controversial Coyote: Predation, Politics, and Ecology.* New York and London: Harcourt, Brace, Jovanovich, 1977.

Reed, Evelyn Dahl. *Coyote Tales from the Indian Pueblos.* Santa Fe: Sunstone Press, 1988, p. 6.

Ryden, Hope. *God's Dog.* New York: Coward, McCann and Geoghegan, Inc., 1975.

Simmons, Marc. *Witchcraft in the Southwest: Spanish and Indian Supernaturalism on the Rio Grande.* Flagstaff, Ariz.: Northland Press, 1974.

Twain, Mark. *Roughing It.* New York: Harper and Brothers, 1913.

Young, Stanley P., and Hartley H.T. Jackson. *The Clever Coyote.* Harrisburg, Pa.: The Stackpole Co., 1951.